Experimental
Packaging

Experimental
Packaging

Compiled and edited by
Daniel Mason

A RotoVision Book
Published and Distributed
by RotoVision SA
Route Suisse 9
CH-1295 Mies
Switzerland

RotoVision SA
Sales and Production Office
Sheridan House
112–116a Western Road
Hove, BN3 1DD, UK
Telephone: +44 (0) 1273 727268
Facsimile: +44 (0) 1273 727269
e-mail: sales@rotovision.com
Website: www.rotovision.com

ISBN 2-88046-509-5

Book designed by Struktur Design
Photography by Xavier Young

Production and separations by
ProVision Pte. Ltd. in Singapore
Telephone: +65 334 7720
Facsimile: +65 334 7721

00_Introduction

Contemporary packaging is all about economics and logistics. Right price, right time, and right place rule the free-market economy with their boots firmly pressed on the jugular vein of creativity only allowing limited supplies of energy to pass through. As a direct result the majority of current packaging is intentionally designed and manufactured to represent a tiny percentage of the overall unit cost of the product of which it is part. Any more, and the packaging is regarded as gratuitous and also cuts into the client's profits.

Practically, it has to look good, protect the contents, stack neatly in multiples and on standard pallets, and not fall off the shelves at point of sale. All of these considerations are very important but ultimately one dimensional and without emotion. The more these decisions are left in the hands of the businessmen the less likely it is that creativity or invention will be allowed to thrive. The contemporary world employs all sorts of other devices to tap into our desires – television and magazine advertising for example. The desire is channelled into these mediums and away from the actual product itself. When you consume things you are therefore consuming the image and not the product. Yet packaging can play an important part in re-establishing a new desire. We are all very media-literate and it is now a widely held belief that we know that we are being sold something. Packaging that is innovative is only innovative because people have either a.) genuinely never seen it before or b.) come across something that is strangely familiar but which has not been seen for a long time.

Contemporary packaging also conforms to very strict conventions. Packaging has to be:

Recognisable – This is most important, as a great deal of time and money has been invested into the product through advertising and marketing. It has to have an immediate positive effect on the consumer to result in a sale. It should also remain in the consumer's memory if they are in a hurry or have caught it in an advert on the TV. Experimental packaging can be instantly recognisable because of its shape, colour, or materials used, and also because the consumer desires it as it looks like nothing they have seen before.

Informative – No amount of TV and press advertising can relate so directly as packaging. 'How to use' information is always a frustration for the designer because it must necessarily appear, and often contains a great deal of copy. Experimentation allows the designer to manipulate this information and consider alternative placing of the text, in some cases making it the main feature of the packaging.

Immediate – While also providing all the relevant information, the packaging is in the consumer's hand, therefore the rapport must be instant. One of the remits of experimental packaging is that it should provoke an immediate response, straight away making the end user question what they are holding.

Textural – Budget permitting, the use of textured materials can raise the packaging above its competitors. Often underestimated, the sense of touch is key to firing off all the other emotions and senses.

Functional – The package should work, just like the advertising said it would. Convenience products are made convenient by all the built-in aids like spouts and holes in powdered floor cleaners. Experimental packaging takes this functionality and subverts it to find more human ways of resolving creative problems. Functionality does not allow for easy cross-fertilisation of materials and processes. Who would have thought that we would be eating crisps and chocolate biscuits out of aluminium-lined tubes originally destined for floor cleaners?

Dependable – This is a very important aspect of standard packaging, especially food packaging today. Hopefully by experimentation new forms of packaging will replace what already exists. Sometimes you cannot improve what has been created but it is fun trying.

The emotional values that are required to create experimental packaging are utilised more than the sense of sight. Packaging can also articulate the following things through its use of materials and processes:

Taste – Sweet, savoury, spicy, soft, tangy, mellow
Smell – Fragrant, cool, exotic, nostalgic
Hear – Smooth, rough, textured
Touch – Crisp, heavy, dainty, contemporary, firm

All of these senses can be satisfied, no more so than today when so much packaging feels the same. They all combine to transcend barriers, target markets, 'media reach' and other such phrases which compartmentalise our waking and sleeping hours. But how can this packaging be created or even explored? There are certain key areas of which it is important to be aware when embarking on packaging that could be potentially classed as experimental.

Materials | Processes

The first thing to realise is that previously held knowledge is the greatest barrier to exploration. The way we interact with the world is based on what we know and believe. It colours our judgement and our ability to consider other options. Design is not a service but a creative process and the designer should harness this ability in the pursuit of alternative ways of exploring a brief. Another barrier in the way of experimentation is the supply chain itself. Print and packaging, in a bid to improve service levels and nothing else, have actually hindered any exploration by the design community. Manufacture is governed by the recovery of overheads and the pursuit of profit at the expense of rising to any design challenge. This is further compounded by the educational community's inadequate resources, and the fact that many design students are not trained to have any great awareness of the two areas listed above. Printing, other than offset litho, is regarded as being best left at college.

It is up to the designer to go about gathering knowledge of these materials and processes. There are many suppliers of both materials and print services within any urban geographical location around the world. They all share the same types of services, but interestingly the application is always a little different and that is a primary opportunity for designers. If you can appropriate the everyday packaging solutions from one side of the world and adopt them for your solution you are somehow experimenting. The appropriation may not be literal but the way you administer the application can be novel. The same can be said of borrowing the materials and processes of one sphere of industry and using them in another. There are rich, untapped veins of materials, processes and ideas in industrial and medical fields that are never explored. One does not need to have high levels of product knowledge but an enquiring mind. It is also worth noting that some of these materials and processes have to be very cheap in their 'correct' application. Therefore you can take advantage of these savings.

Experimentation with packaging forms is also reliant on knowledge of materials in particular. All materials have different properties, some of which do and others that do not allow you to manipulate the material how you would like. A flat sheet of material cannot be folded or held in a curve without a lot of complication. Therefore what other shape can be created or at least create an approximation?

A container breaks down into sides, lids, bases, tabs, flaps, slots and closures. Some have very important jobs to do to protect and support the contents. By utilising materials other than paper and board these elements take on different characteristics; a closure, for example, when fabricated in plastic, looks almost sculptural – its features should be advertised as a key part of the packaging.

Processes should also be considered as alternatives to the lift-off lid box. It is true to say that they incorporate expensive tooling and long production times but processes such as vacuum-forming, high-frequency and ultra-sonic welding can be relatively economic if engineering out of a flat sheet of material is not fulfilling the idea.

Another aspect for consideration is that packaging should be regarded as vital as the contents it is encasing. Packaging has the ability to:

Protect – Many devices, materials and processes are used to achieve this. The hinges and locking devices that can be created through cutting, scoring and creasing materials are endlessly inventive.

Tempt – How can the designer engender this feeling in the end user? Can this only be achieved through materials or can the way a box is constructed add to a Pandora's Box-like sensation in the end user?

Decorate – Can over-elaborate use of materials and packaging devices augment the end result?

Add value – The implication of this phrase is that there was no value there in the first place, but can packaging be made more valuable than the contents?

The contents of the book hopefully go some way to teasing out some particular examples of what we consider experimental. Our choice has been highly subjective and, in certain cases, comes as a result of wild post-rationalisation. It would have been very tempting to include mounds of record or perfume packaging. What we have pulled out is a broad spread which is neither representative or meant to convey that certain spheres of industry promote creativity and innovation over others. Our conclusion is that all areas of product development need to explore packaging a bit more and the examples featured demonstrate that this can be achieved.

In this digital world the need to experiment has become a meaningless, finite pursuit. The tools we have at our disposal render the creation and exploration of ideas a relatively simple task. These tools speed up the process, leaving the original concept an easy thing to achieve, and therefore a little exposed to criticism and self-doubt. The need to experiment, to find out how something works, has been replaced with the need to experiment to demonstrate known facts. It is true to say that experimentation is needed to improve the world we live in, but in a culture that is being constantly inundated with new material artefacts there seems to be little point. Too much emphasis is placed on resolving things quickly with little regard for other more workman-like methods of execution. In design, packaging is the most difficult area in which to be innovative and revolutionary. The interface with the digital renders packaging meaningless. Packaging is not required when the information we want can be accessed with far greater speed. Packaging allows us to be aware of more of our senses, makes us less lazy in our perception of the world. We all can glean informational data to feed our knowledge but packaging can create desire for things. It can make certain information more important because it has been presented in an unexpected way. As a designer it puts you in touch with the process of manufacture, enabling production of more than one idea. The challenge is not to copy but to explore new ways of creating the tactile experience with the end user. Packaging has not been pushed to extremes with circumstances. It is more about the design process allowing an understanding of the end user's senses. These examples demonstrate awareness of process and materials coupled with a desire to create something new and exciting without compromising other methods of communication. Ideas are there to be re-invigorated. Use three dimensions.

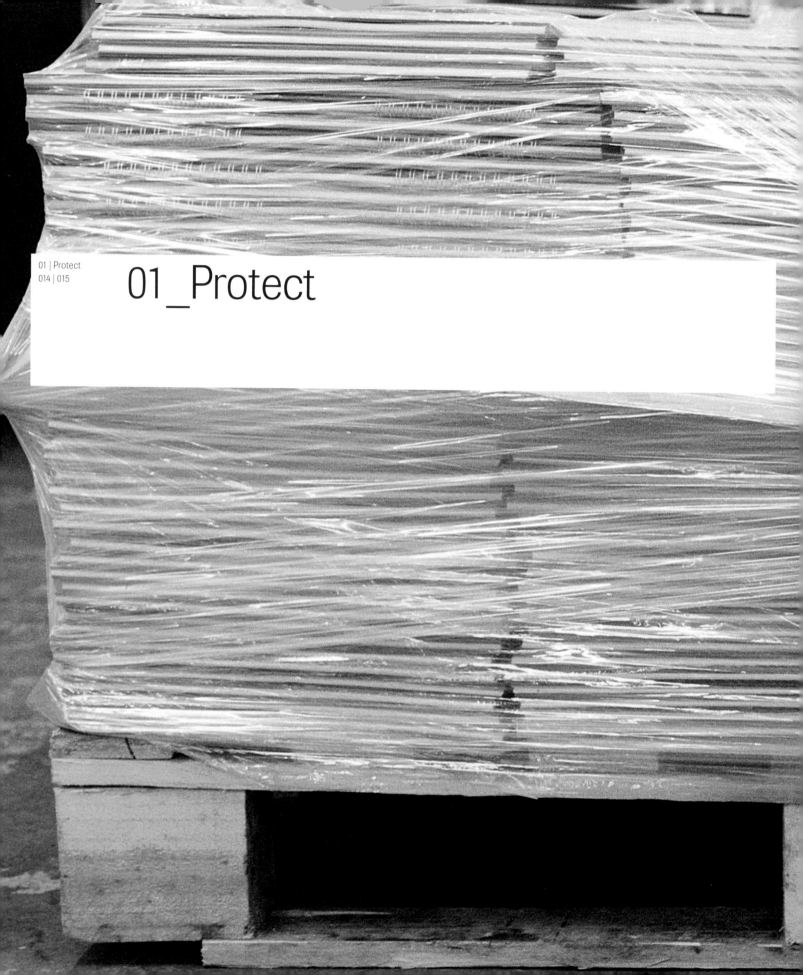

01_Protect

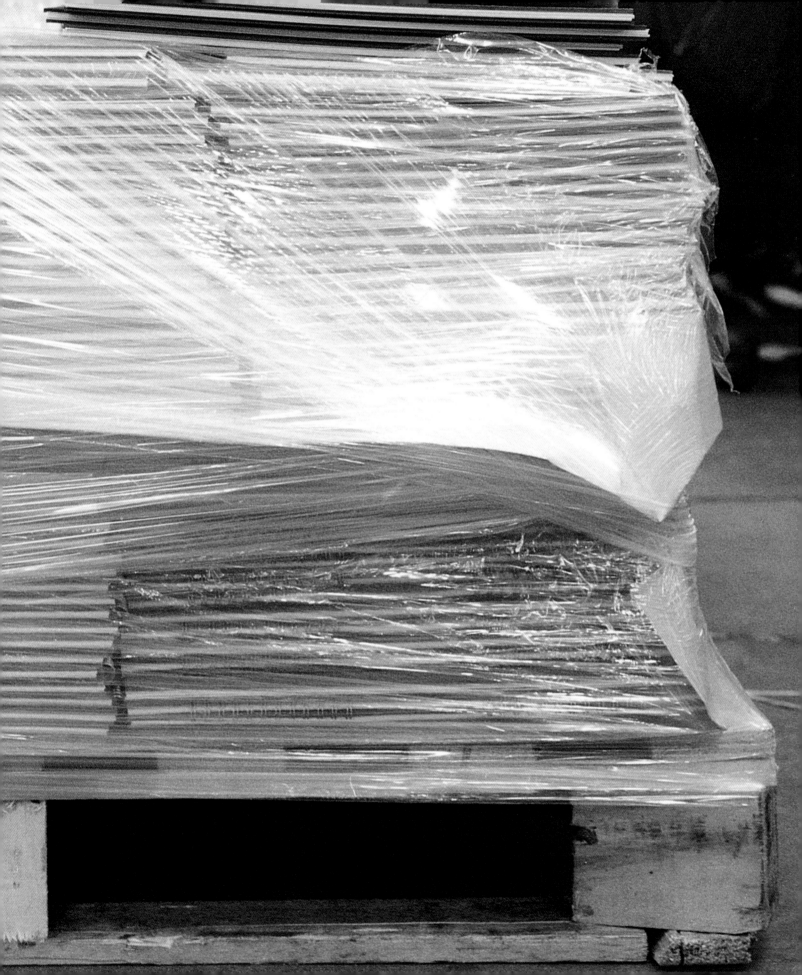

	Project	**Torus Case**
	Design	**Marc Newson**
	Client	**Syn Productions**
	Materials	**Plastic**
	Origin	**Japan**

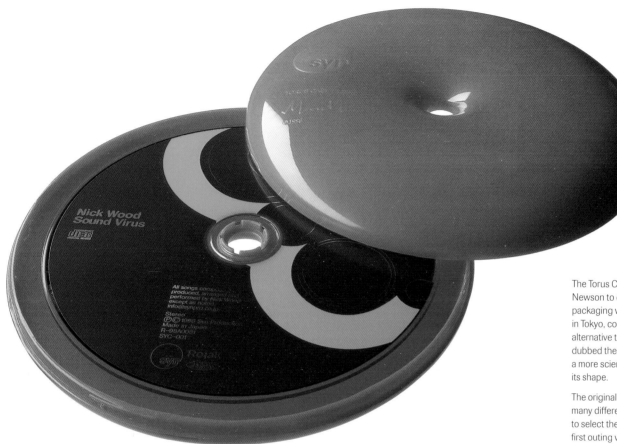

The Torus Case was designed by Marc Newson to create a new form of CD packaging which the client, Syn Productions in Tokyo, could use as their corporate alternative to the jewel case. Originally dubbed the CD bagel it was eventually given a more scientific name, Torus, to describe its shape.

The original idea was to create the design in many different colours allowing the customer to select the colour that was right for them. Its first outing was for the launch of the 021C car, also designed by Newson for Ford. The orange colour was selected for its link to the 021C colour of the car. The circular injection-moulded lid and base has a screw mechanism to gain access. The injection-moulded process is commonly used in the manufacture of solid plastic objects where accuracy and durability is required. One only needs to look at the levers and buttons in a car to realise where this process is applied. There is something very satisfactory about this case when it is held in the hand. It is organic in form, yet at the same time smooth and pod-like. The other interesting point to note is the circular CD leaflet, a section of which is cut out to allow it to sit over the central hole.

It is interesting to point out that the same injection-moulding process is used to fabricate the styrene jewel cases that normally house CDs, giving it a familiar feeling. The end result is a decorative object that challenges the conventions of music packaging – a lifestyle product that informs our perception of a car and the music that often accompanies the driving experience.

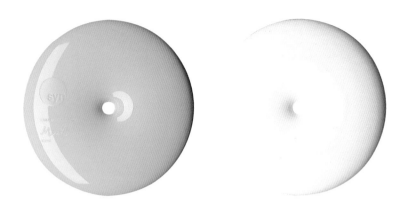

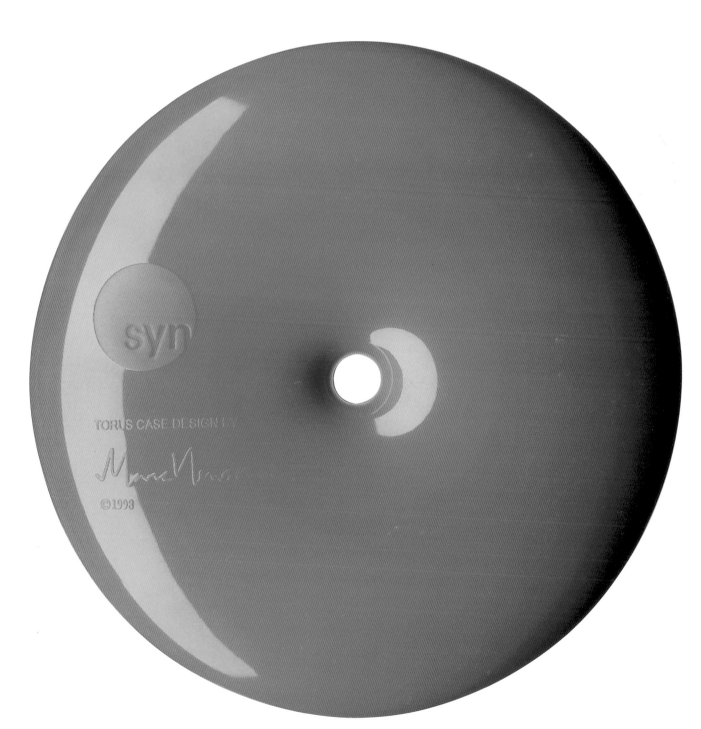

syn

TORUS CASE DESIGN BY

©1998

Project	For promotional use
Design	Tony Hung
Client	Adjective Noun
Materials	Corrugated cardboard, packing tape, black anti-static bags
Origin	United Kingdom

With books and brochures that are created to promote the company you own or work for the only client you need to impress is yourself. A great deal of thought goes into these projects where a company philosophy has to be explained and a client list has to be presented along with a smattering of work from your portfolio. In the case of this self-promotional exercise, Adjective Noun created 48 packages that were sent to all the people who have supported them – an experimental concept in itself. Primarily working for record industry clients this type of packaging execution would be greatly appealing to the end recipient over yet another brochure or postcard.

Adjective Noun's original concepts were incredibly ambitious at the start of this project. One idea to replicate the t-shirt design as a three-dimensional, moulded-plastic, erupting volcano was quickly rejected due to timings, cost and fire regulations. The designer returned to a more low-cost approach by appropriating a large number of ready-made available bags and pouches. A packing tape was specially designed and manufactured along with the screen printing of the outer box. Once again an existing box construction was utilised in which was placed a t-shirt and an enamel box. To save costs even further an existing cutter was used to enable more of the designer's budget to go into the two promotional items.

The packaging is a very engaging experience if you are fortunate to receive one of these boxes. It is not particularly easy to open and you feel you are destroying a great many layers of material to get to the contents, leaving you with a large pile of plastic, tape and cardboard. As a packaged object it is very beautiful yet it has a Pandora's Box-like quality that demands that it is destroyed. It is interesting to note that the designer regards the packaging as integral to the contents. There is nothing of a luxury quality about the materials used but it has echoes of more expensive packaging in its limited colour palette and the limited number produced. The hand numbering also adds to its exclusivity.

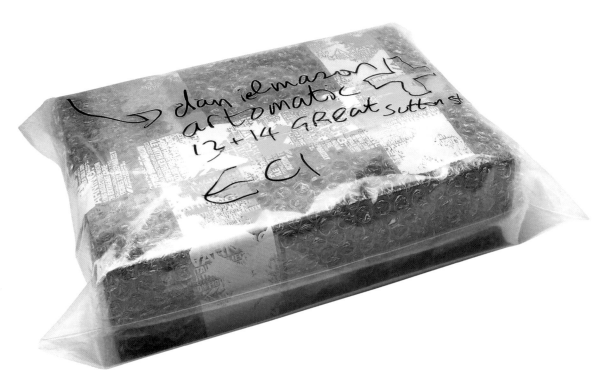

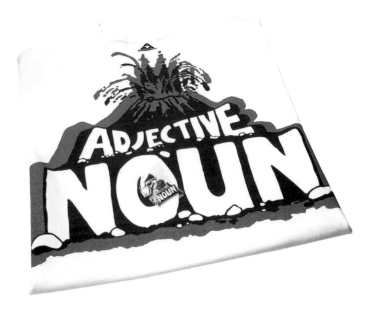

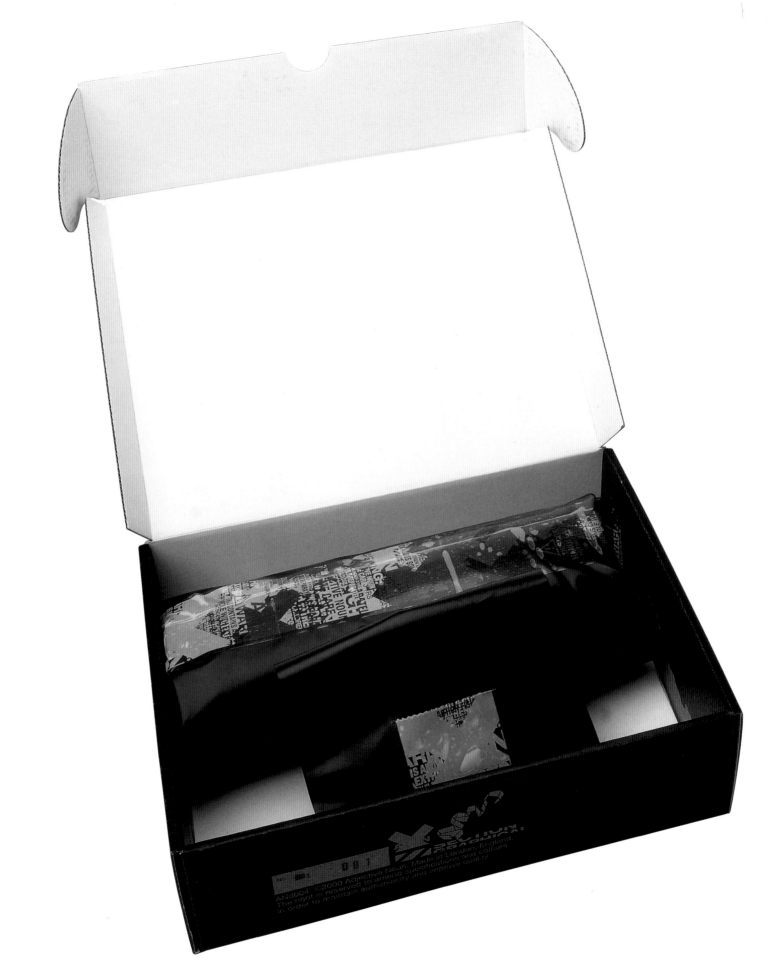

Project	**MB R 251**
Design	**Michael Bischoff Schmuck and hdr design**
Client	**Michael Bischoff Schmuck**
Materials	**Felt, wood, high-density foam**
Origin	**Germany**

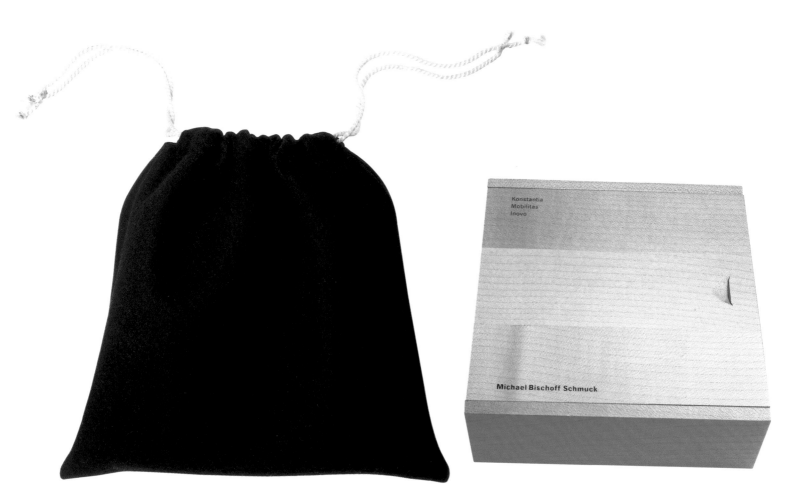

Working closely with the German jewellery designer Michael Bischoff Schmuck, hdr design has produced all their brochures and promotional items over a period of time. The jewellery follows very stringent modernist principals of form, working purely with basic shapes – square, circle and triangle. In recent designs these basic shapes have been further reduced to just the square and the circle.

All promotional materials designed by hdr design follow these basic principals, by working purely with the square and a reduced palette of colours. The packaging is also influenced by artists such as Josef Albers, Mark Rothco, Josef Beuys and Richard Serra, as well as the poets Eugen Gomringer and Dom Silvester Huidard.

The wooden box is a simple purist form. Presented in a drawstring black felt bag (for protection) the box, made from wood, is exquisitely produced putting the emphasis on quality and craftsmanship rather than on complexity and gimickry. The box lid slides gracefully to one side to reveal eight rings set in a sheet of high-density black foam. The rings are produced in various coloured stones and precious metals, which can be combined together because of their curved forms to create numerous variations.

The box works for point of sale and for daily use after purchase, making the packaging an integral part of the product.

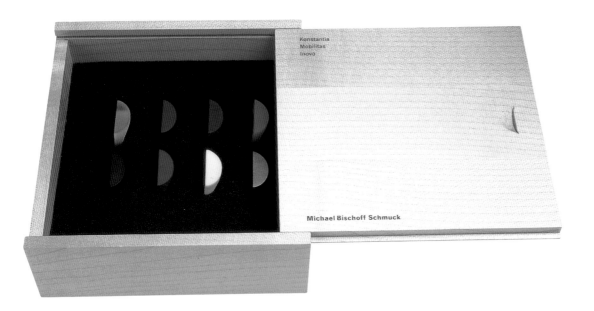

Project	**MB R 327**
Design	**Michael Bischoff Schmuck and hdr design**
Client	**Michael Bischoff Schmuck**
Materials	**Felt, wood, high-density foam**
Origin	**Germany**

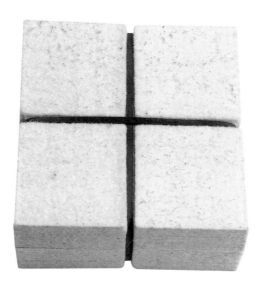

Continuing their collaboration, Michael Bischoff Schmuck and hdr design created the packaging solution for this complex ring – the ring is constructed from four square pieces of gold – white, yellow, rose and red. The layers are secured in just one corner, which enables the sections to be fanned out to reveal the different colours.

The packaging is again based on the square. This time the ring is placed within a recessed slot (half the depth of the ring) in a 100mm-square block of high-density natural white felt (similar to the kind used for buffing metal). An identical block is then placed over the top to encapsulate the ring. The two halves are secured by two black elastic bands which sit within recessed grooves that form a cross over the surface of the block (dissecting the block into four smaller squares).

The felt block is housed inside a wooden 'U'-shaped container which has a very matt-textured finish. The package is completed by a wirebound book which contains background information about the ring together with typographic experiments based on the four colours of gold used. These typographic experiments are followed by two sets of photographs, firstly showing the ring in a clinical graphic manner to explain the possible interaction the user can have with the object, and secondly showing the ring more expressively.

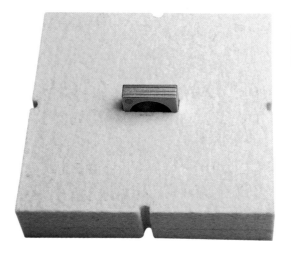

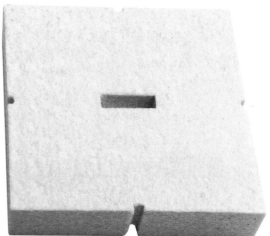

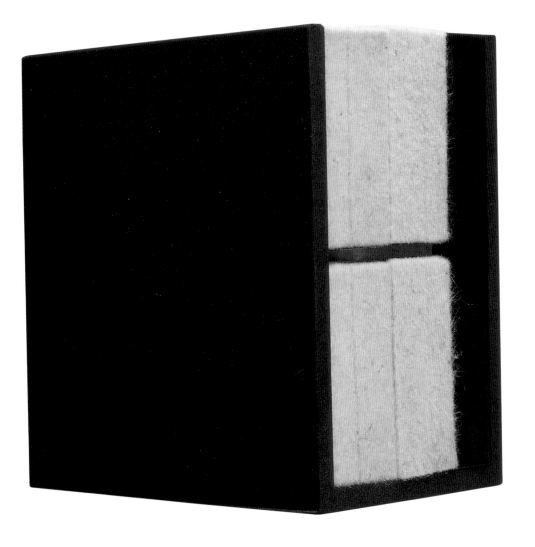

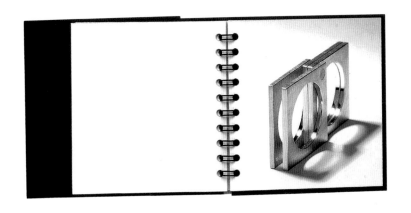

	Project	**Prada Beauty**
	Design	**In-house**
	Client	**Prada**
	Materials	**Tyvek, PVC, board**
	Origin	**Italy, United States of America**

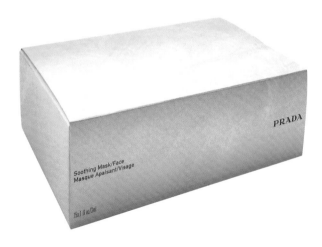

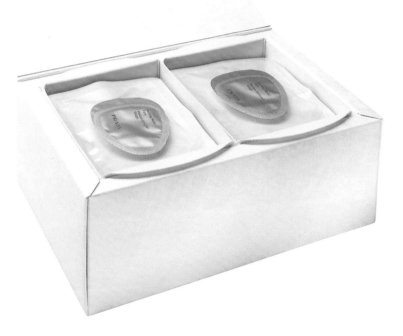

The principle aim for this packaging was to preserve the complex formulations that formed the basis of this Prada skincare range. The number of preservatives in the individual formulas is kept to an absolute minimum, hence the need for 'single dose' packaging. All the materials have the ability to keep out the damaging effects of light, air and even bacteria for each single treatment. The range consists of 26 products all performing different functions and these were packaged in a number of ways.

The packaging execution is very deliberate for very intentional reasons. A great deal of time and care goes into the selection of materials. Once the client is happy that their needs had been satisfied then the selection of colours and shaping of the vacuum-formings takes place to ensure that it sits within the Prada lifestyle aesthetic.

The outer carton packaging is made from Tyvek, which has been laminated to folding boxboard. The box closes on the side with a thin magnetic strip. Inside the outer carton there are two individual trays with crash bottoms. On each tray are two shaped returns which hold the trays in position. The green-tinted polyester film that seals over the individual foil-covered formings matches the coloured strip on the box and the bond paper leaflet that sits at the base of the box.

All of the other items in the range are either housed in packaging of a similar manner – foil-covered, vacuumed-formed tray, heat-sealed in a tinted polyester film and Tyvek sachet – or in a range of small plastic tubes or bottles. All are branded with the Prada logo.

The inference of the medical, pharmaceutical or optical contents is there but never overt. There is no outward showy display normally associated with skincare products. It is true to say that the packages share the muted tones and white finish of most skincare ranges but without appearing forced or trite; form follows function in every respect. Viewed in total they are very elegant. They are even sold in Tyvek bags with the word 'beauty' discreetly printed in the gusset. The bag is also a technical feat as most bag manufacturers, and most printers, are scared of this material which is notorious to print on and convert. The production language has been appropriated from the industries listed above but the final execution is much lighter and delicate in feel.

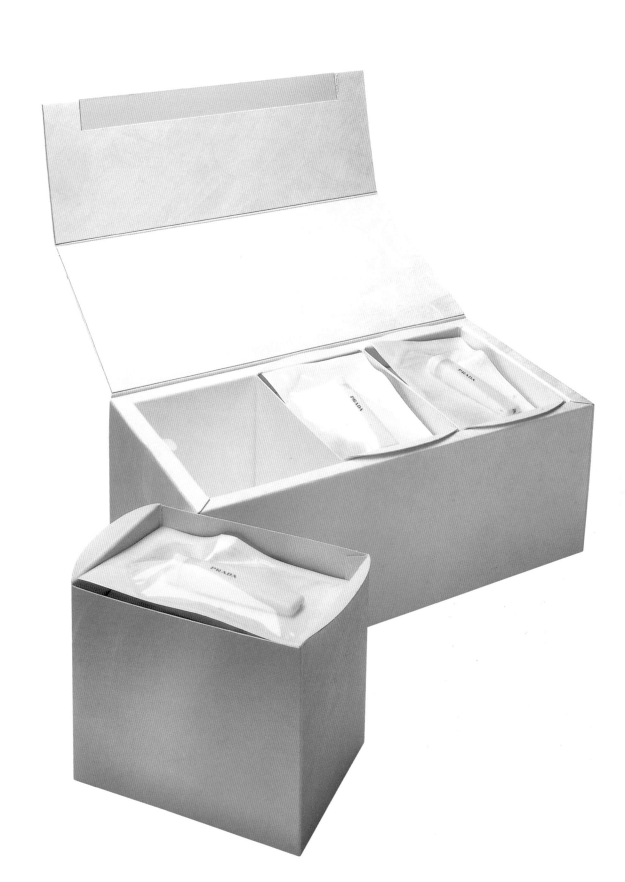

Project	Prada Beauty
Design	All products were designed in-house at Prada
Client	Prada
Materials	Tyvek, PVC, board
Origin	Italy, United States of America

Soothing Mask/Face Masque Apaisant/Visage Beruhigendes Maske/Gesicht

Instant comfort for stressed, sensitive skin. Calms skin and helps it behave more normally with bio-energy of plant extracts.
Confort instantané pour les peaux stressées et sensibles. La bioénergie d'extraits végétaux naturels calme l'épiderme et l'aide à se comporter plus normalement.

Function/Propriétés	Instructions for use/Mode d'emploi
Instant relaxation and reduction of redness. Relaxation instantanée et atténuation des rougeurs.	Apply even layer to clean skin. Wait 15 minutes. Tissue or rinse off. Follow with moisturizer.
For/indication Occasional skin stress. Stress occasionnel de la peau. **PRADA**	Appliquer en couche uniforme sur la peau nettoyée. Attendre 15 minutes. Essuyer ou rincer. Faire suivre de soin hydratant.
Texture Gel mask. Masque-gel.	
Fundamentals/Composition Pure Aloe vera base, horse chestnut extract. Base d'aloès pur, extrait de marron d'Inde.	**Assurance** Dermatology-tested. Tests dermatologiques effectués.
Keep in envelope until ready to use. See enclosure. Gardez dans l'enveloppe jusqu'à prêt a l'usage. Behalten sie das Produkt bis zum Gebrauch im Umschlag.	
Made in U.S.A. **Dist. C.I.D. Cosmetic International** Distribution SA Luxembourg	www.prada.com 6

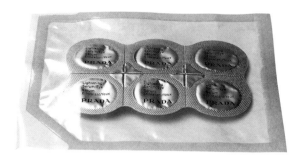

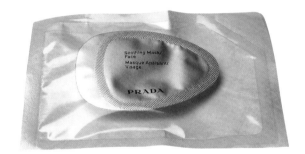

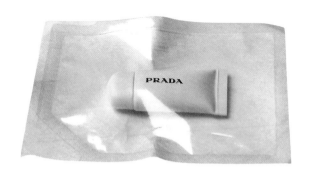

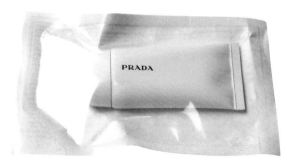

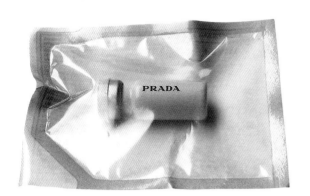

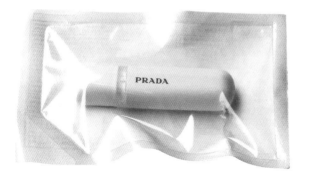

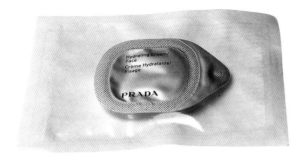

01	Protect	**Project**	**Burial Kit for the 21st Century**
028	029	**Artist**	**Inventory**
	Materials	**Flexible PVC, nylon zip**	

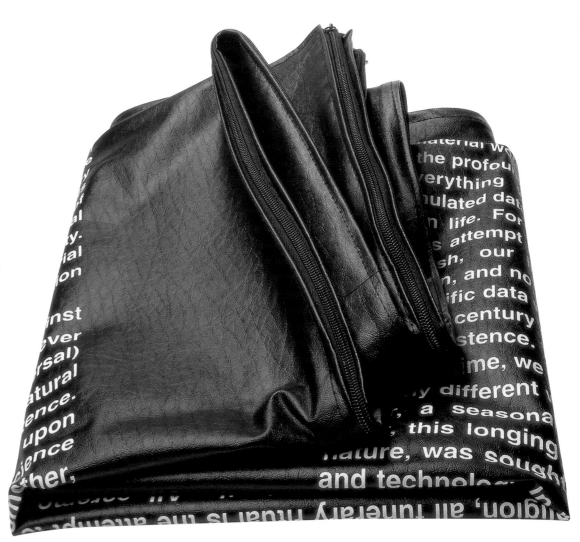

Inventory, amongst other artists, was commissioned to design an alternative to traditional funereal artefacts such as coffins and urns which, however unusual or bizarre, could nonetheless be used at a real funeral. These creations were exhibited in London and Cumbria. The intention primarily was to reframe and reassess this final rite of passage in a creative and thoughtful way.

Much of Inventory's previous work has involved text combined with some object or image in a bid to grasp experience from all angles. This desire was translated into a body bag for this project. Initially the artist wanted to print on a bin liner. However, it is not possible to print effectively on polythene so an alternative had to be sought. An average body bag of 3m in length was selected, other sizes being too small for human dimensions. The bag used had a zip on three sides, and a 1,000-word essay covering the maximum print area on one side only. The finished result, ten of which are in existence, looked like a modern day sarcophagus. The body bag is also manufactured with a natural flexible PVC identification card pocket. In place of this is a photograph of a woman at a demonstration in London organised by Reclaim the Streets; she had embroidered on the back of her jacket the words 'work, buy, consume, die'. This was intended to mirror the words on the bag.

It could be rightly argued that there is nothing experimental about a body bag. However, the appropriation of this article to explain a message is thought-provoking. It's strange to think that this black, flexible PVC is manufactured for the use of body bags and coffin linings when the white colour, produced by the same company, is used to line baby's cots and changing mats. Birth and death in one material.

"So what are the material conditions of our existence? The objects we have made? The projects, the products, the ideas we have fashioned? Or is this trust, this faith in our material inventiveness, this idealised construction of 'man the toolmaker' merely the symptom of what seems like an eternal frustration, an anguished state of incompleteness?

"Our material world, the moraine of our existence, provokes nothing more than the profoundest disquiet. Supposing we were to make an inventory of everything we owned, all our possessions. What could this accumulated data say to us? – Nothing more than the extreme poverty of modern life. For all our constructions, our technologies, our material cultures attempt to mask our corporeal existence – our true materiality. Our flesh, our bones, our laughter and screams are our material condition, and no intellectual formulation, no technological construction or scientific data will bury this understanding indefinitely.

"A deeper understanding of death should make us sovereign authors of our own unlimited imaginings and joyous communions driven by a fundamental principle of life – to exceed itself purposelessly. A life composed of so many perishable moments, both cruel and loving; for which there is nothing to be regretful or guilty for. You could stand on the highest hilltop, trembling with anguish, shaking your fist at the heavens and what will it soothe for you? What can it assuage? – NOTHING. Therefore, this nothingness can only be willingly embraced. For as we drown in that dark and empty void, we refract back at ourselves, rendered in sharp detail, as much more than a mere shadow in a discontinuous landscape.

"There will never be enough time; this is why we should cherish life, and why we fear death – because death completes us."

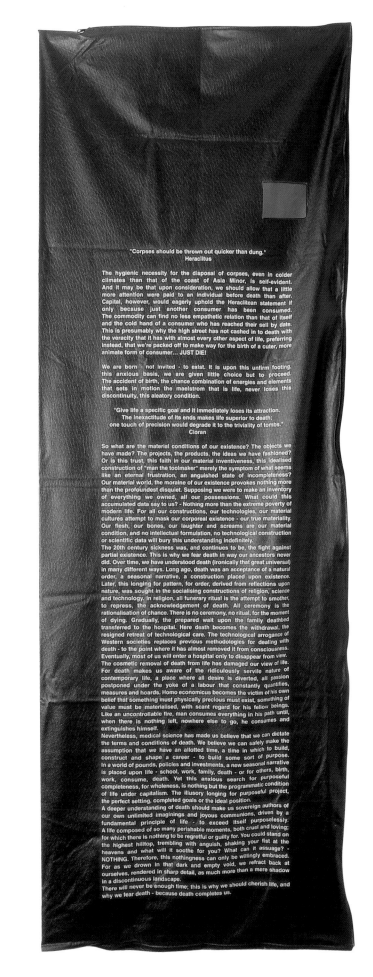

Project	Radiohead 'OK Computer'
Design	Stanley Donwood
Client	Parlophone
Materials	Polystyrene, board, styrene, paper
Origin	United Kingdom

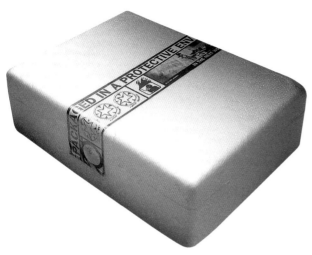

The title of the Radiohead album 'OK Computer' was the direct influence on the final design execution for this promotional piece. It was decided that the packaging should allude directly to the packaging of computer parts but more substantially. It would have been so easy to pack everything in an anti-static bag but it was felt that this would be too obvious.

The polystyrene outer box was specifically engineered and manufactured in Japan. It seems such an extreme geographical distance for the manufacture of such a complicated component but it proved to be cheaper to do it there. There were no complicated diagrams, drawings or instructions, just a single-minded determination to achieve the result of the briefest of conversations. The tooling for the polystyrene lift-off lid-box was the most time-consuming and nerve-wracking but the CD and video cassette components already existed and could be fitted perfectly.

Including the printing of the Jiffy bag (lyrics to one of the songs incidentally), the whole idea took ten weeks from conception to delivery. The strip holding the two sides together offsets the graphics of the packaging on the inside, allowing emphasis of some of the key icons from the album's artwork. Five hundred were produced and distributed to the media and fans.

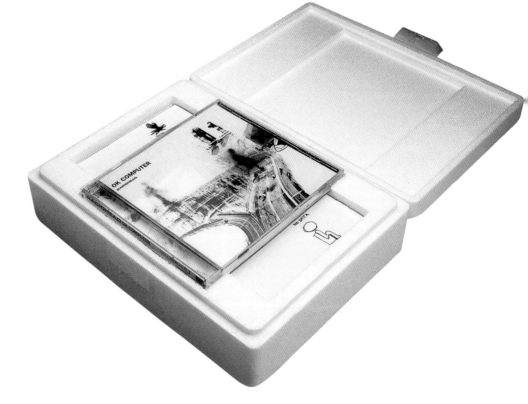

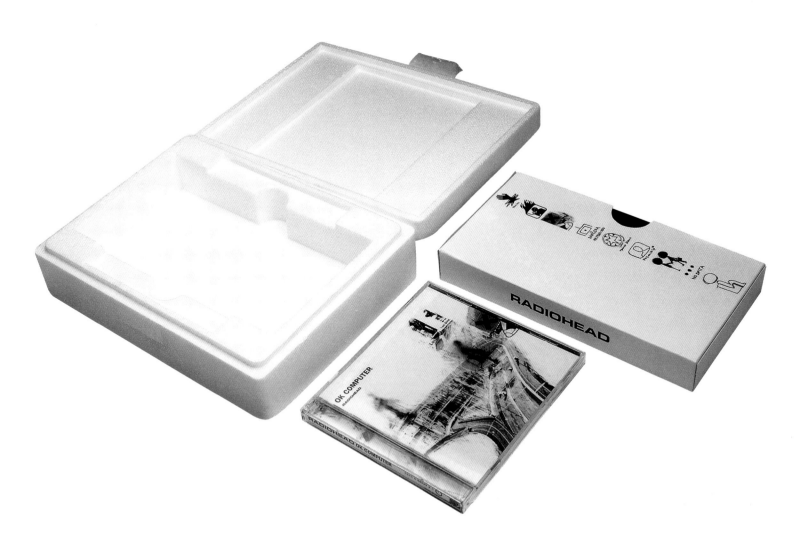
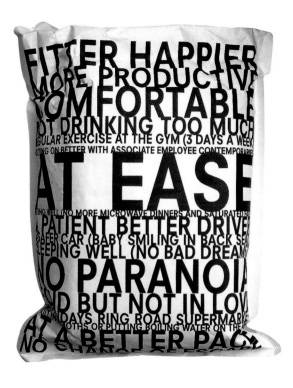

Project	Air Titanium Case
Design	Lindberg Optic Design
Client	Lindberg Optic Design
Materials	Plastic, pearwood, leather, metal
Origin	Denmark

Lindberg Optic designs and produces a whole range of optical products created from titanium. The process creates glasses which require no screw fixings, the glass being secured by bending and forming the metal around the lens. Because of the titanium, the specticals weigh only a few grams, but are very strong and flexible.

This originality of design is carried over into the case. Again a simplicity of form is employed – two plastic or pearwood side panels are held in place by a sheet of sprung steel. The case is opened by 'peeling' open the metal cover, which gently springs open to reveal the glasses.

The case, together with the specticals themselves, has won numerous international design awards for originality, innovation and form.

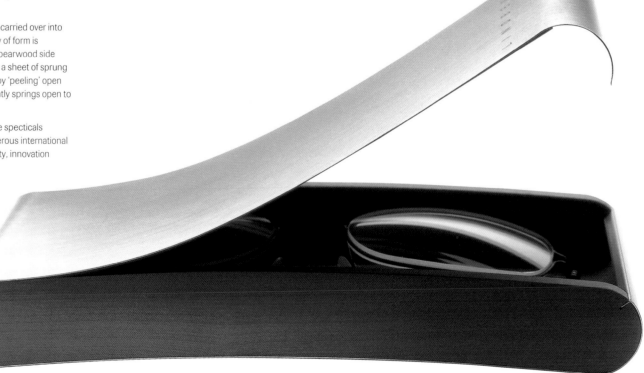

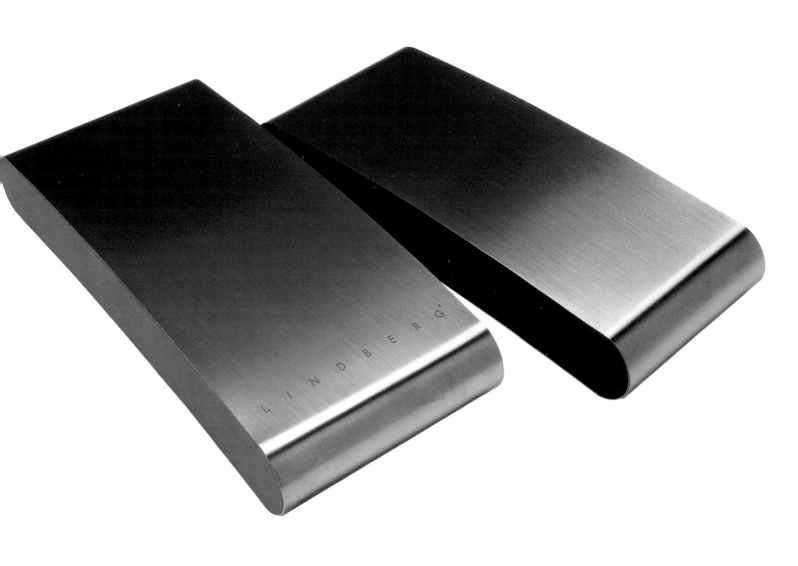

Following six years of research Swedish tennis ball manufacturer Tretorn made a major technological breakthrough when they developed a method to pressurise a tennis ball with 700 million perfect, round, air-filled, balloon-like polymere micro cells. This innovative development means that for the first time there is a tour performance tennis ball on the market which does not lose pressure or performance over time.

The literal translation of Tretorn is 'three towers', a symbol of which is used on some of their corporate material. Pentagram decided to convert that idea and use a triangular shape for the packaging, creating a strong physical identity and corporate image. The tube is produced in black polypropylene, with an embossed detail reflecting the 'x' brand. The tubes have transparent tops which allows the product to be visible at point of sale.

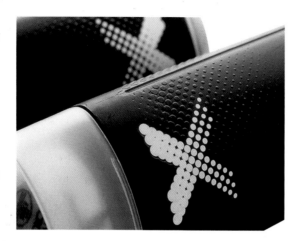

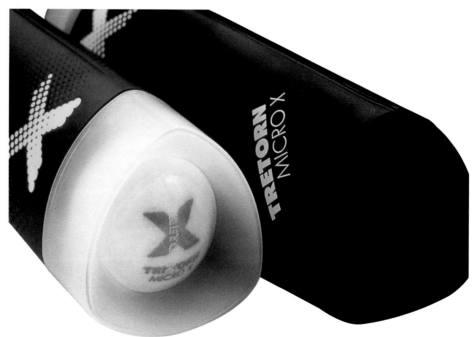

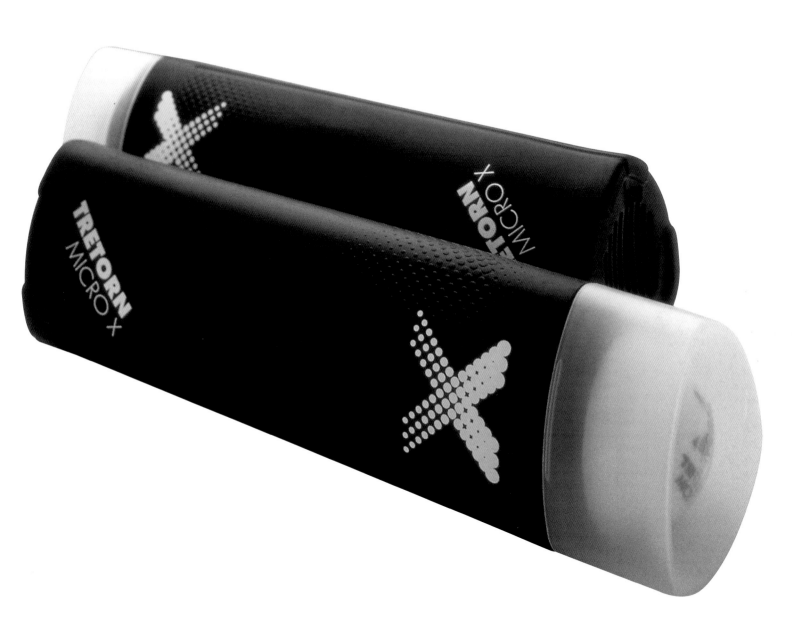

The Getty Images Catalogue followed in a line of evermore complicated packaging and book solutions for the Getty stock library images. The use of expanded polystyrene packaging lends itself to the glow-in-the-dark cover of the book. The themes of industry, science and the future are all addressed here through judicious use of existing packaging. The polystyrene makes the box warm to the touch, serving to enhance the glowing book held in its base. Polystyrene powder is injected into a die-cast and polished-steel tool, the powder expanding in the mould to create the packaging, a material commonly used to mould the packaging that surrounds electrical hardware in transit. The choice of the material strangely decorates the box, at the same time protecting it from damage in transit. The processes are unusual for such an item, yet add to its attraction. The book only has coherence as an object with the box, and most end users find themselves keeping the whole object together when normally the box would be discarded.

The world of photo libraries is very competitive with each company offering more or less the same range of images. This packaging only serves to augment Getty's image as a company that can offer the most innovative pictures, ideas and service.

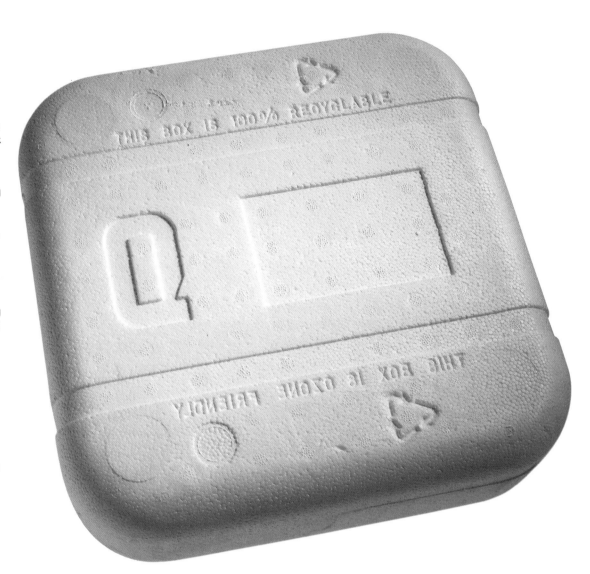

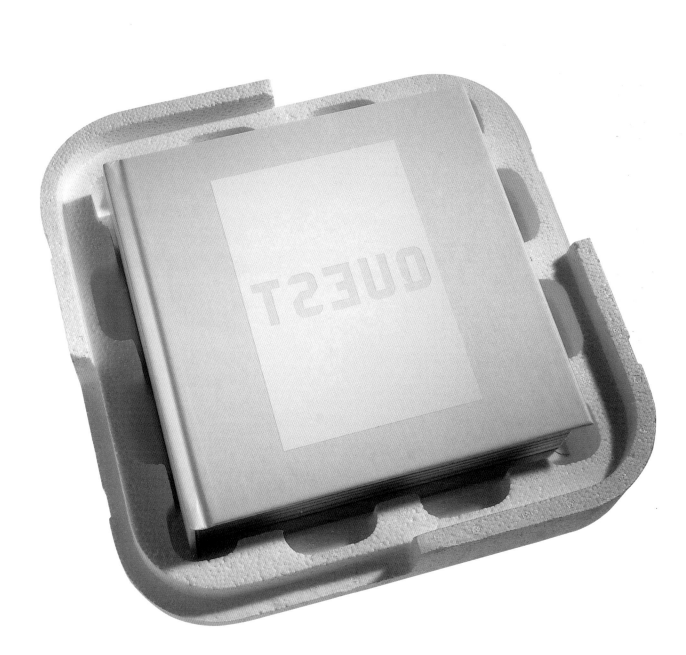

02_Desire

Project	Gasbook 8
Producer & Editor	Akira Natsume
Co-ordination	Xiaomong Jiang
Design/Art Direction	Hideki Inaba
Publisher	Takeyuki Fujii
Published by	Design EXchange Co., Ltd.
Materials	Card, plastic
Origin	Japan

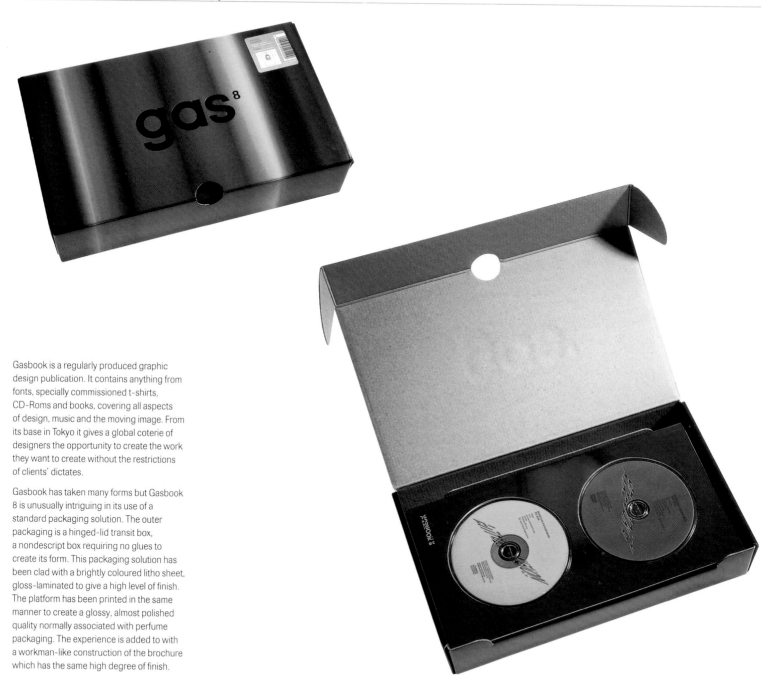

Gasbook is a regularly produced graphic design publication. It contains anything from fonts, specially commissioned t-shirts, CD-Roms and books, covering all aspects of design, music and the moving image. From its base in Tokyo it gives a global coterie of designers the opportunity to create the work they want to create without the restrictions of clients' dictates.

Gasbook has taken many forms but Gasbook 8 is unusually intriguing in its use of a standard packaging solution. The outer packaging is a hinged-lid transit box, a nondescript box requiring no glues to create its form. This packaging solution has been clad with a brightly coloured litho sheet, gloss-laminated to give a high level of finish. The platform has been printed in the same manner to create a glossy, almost polished quality normally associated with perfume packaging. The experience is added to with a workman-like construction of the brochure which has the same high degree of finish.

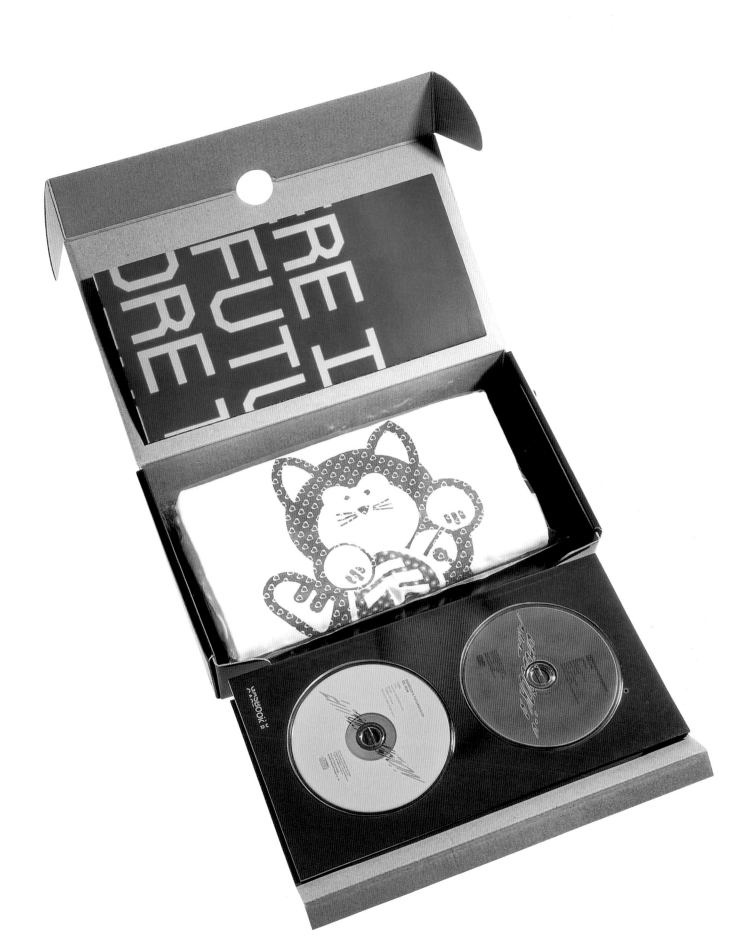

Project	Airmail Dress
Graphic design	Rebecca and Mike
Client	Hussein Chalayan
Materials	Tyvek
Origin	United Kingdom

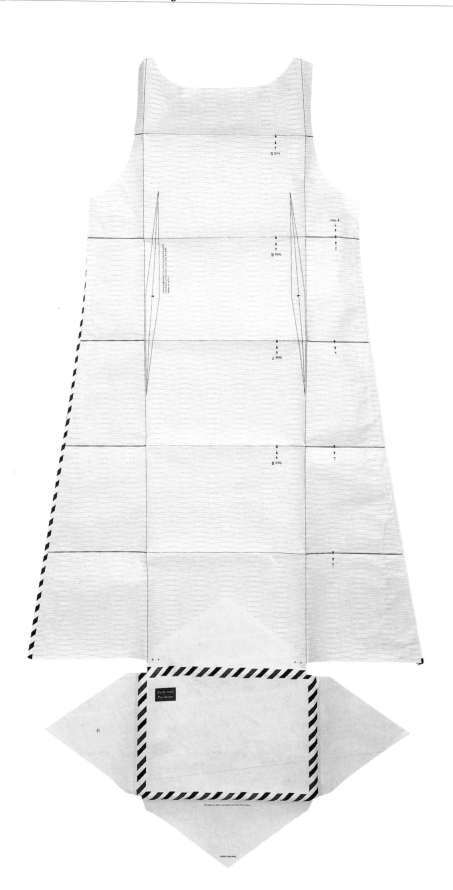

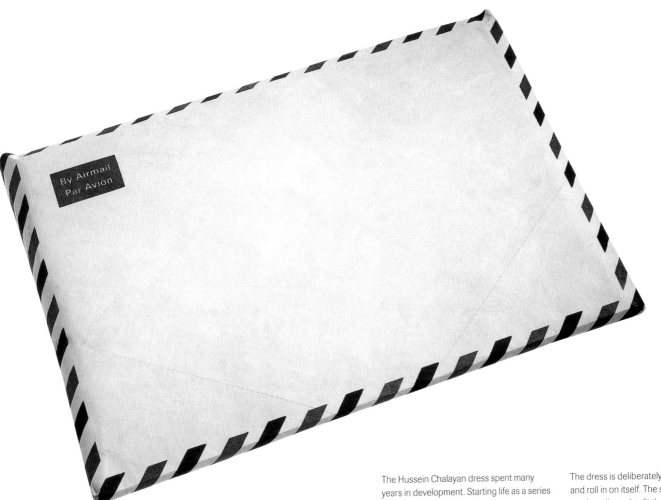

The Hussein Chalayan dress spent many years in development. Starting life as a series of garments, the dress was the only garment that went into a production run of 200.

All the globally renowned courier firms use Tyvek for their document envelopes. Tyvek is made of pure polyethylene fibres randomly laid and compressed to form a remarkably tough and unrippable substrate. It has been used for tags, banners and signs, but is usually restricted to industrial applications.

In this case, Tyvek is used imaginatively to create an object which can be regarded as clothing, art or a letter. The original intention was to ignite a debate about the notion of letter writing. When we communicate in writing we feel free to express our thoughts. A message sent is easier than a message told. Written thoughts seem to simplify the abstract into the concrete. Airmail clothing can be altered by the wearer/sender into a 'garment of thoughts'. The body becomes a tool of expression, but this is a tool that can be sent and given to someone else.

The dress is deliberately constructed to fold and roll in on itself. The size of the garment can be adjusted to fit through use of perforations and adhesive labels. Despite the manufacturer's literature, Tyvek is a notoriously difficult material to convert, print and work with. The use of the wrong ink system reacts with the material making it roll into a tight tube. A great deal of research was undertaken to ensure that the design could be printed. Despite the fact that the material is very rigid and the finished result lends itself to being framed, more domestic tests were undertaken by the printer, to ensure it would wash. Surprisingly for the material manufacturer it was discovered that it actually softened when washed.

Hussein Chalayan's work is at the cutting edge of fashion for its use of materials and design. The dress is an unusual collaboration of fashion designer, graphic designer and printer.

Project	MicroMusic 2000 Packaging
Design	Peter Saville Studio
Client	London Records
Materials	Coloured uncoated board, polythene grip-lock bags, black bubble wrap
Origin	United Kingdom

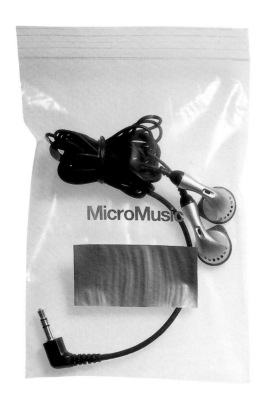

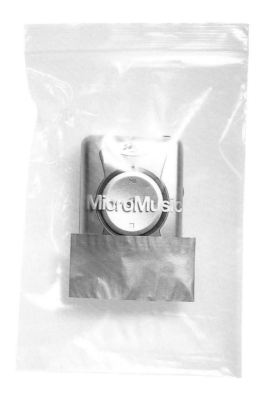

The work of Peter Saville is well known to designers and consumers of music. His graphic work for the record industry has been ground breaking in its treatment of the concept of 'band as brand'. This promotional item is a departure from his usual work, as the music is now treated as a product, itself a three-dimensional form. Various packaging solutions had been discussed with regard to this promotional project. Not only was the promotion of London Records artists a necessary marketing activity but the way this

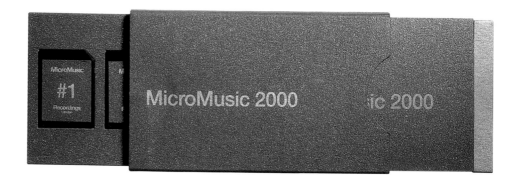

information was delivered had to be treated in the same way. The MicroMusic digital music system is a new innovation in recorded music. There are, at present, no plans to release the music player commercially. The music is recorded to small chips, each containing up to three hours of music. The packaging for this promotional release was to reflect the styling of the player while complementing its livery. The patented construction of the Burgopak carton only allows you to use paper and board materials. It was fortunate that

there was a metallic board which matched the outer casing perfectly, the typography being screen printed. The packaging system allows the user to pull one drawer open, the other miraculously sliding open at the same time. This is achieved via a band of thin PVC which is drawn around both elements. The rest of the packaging comprises deliberately low-grade, pre-printed, clear plastic polythene grip-lock bags and anti-static black bubble wrap pouches, echoing the packaging of high-value electrical goods. The intentional

use of found packaging allows the chip packaging to be regarded as a piece of hardware in its own right. It is interesting to note that this packaging solution, while at first appearing complex and expensive, is simple to apply to the larger CD format. In an industry which looks for new ideas and greater economies of scale, the Burgopak represents the way forward for commercial CD packaging in a world where recorded music's future is uncertain.

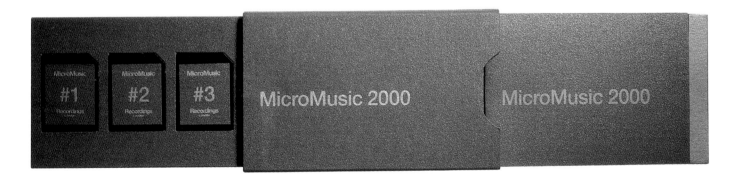

Project	Cultural Ties Packaging
Design	Gareth Hague
Client	Cultural Ties
Materials	Injection-moulded styrene, high-density foam, uncoated paper, holographic polyester film
Origin	United Kingdom

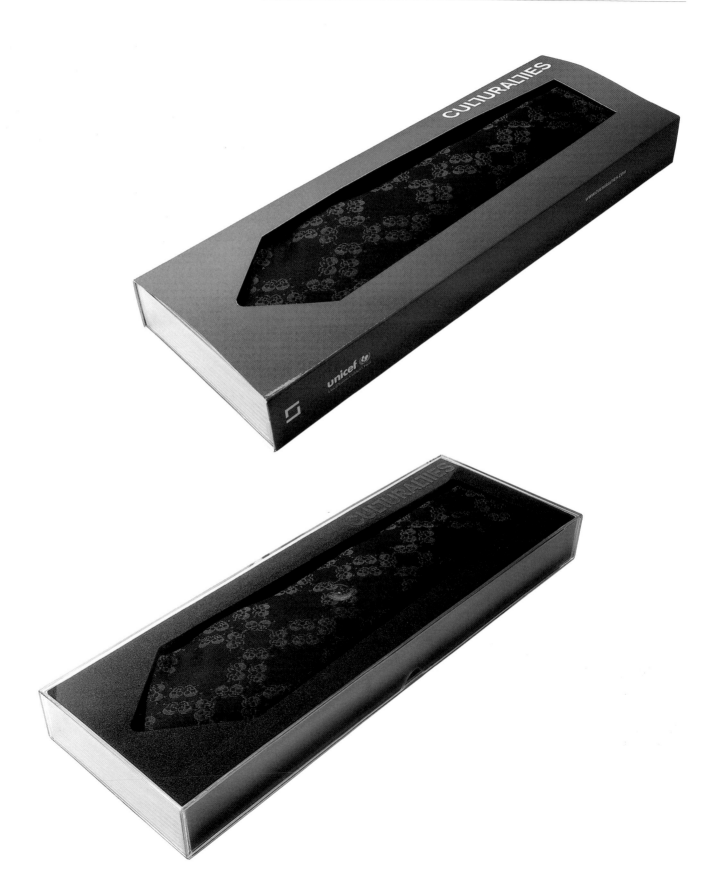

A number of production process were discussed, rejected and variously employed on the packaging of a numbered edition of 150 ties designed by some of the world's leading contemporary artists from Jeff Koons and Yoko Ono to Jake and Dinos Chapman.

The original concept had been for something completely clear with the tie 'floating' within a box of some construction. The materials under consideration were PVC and clear polypropylene, none of which were acceptable for such a high-value item. Both materials, in flat-sheet form, can only be bent, creased or scored, only allowing for the packaging to be glued or tabbed together. A number of prototype versions were constructed, all of which were too similar to the type of packaging normally associated with dolls in national dress bought at tourist attractions. The high-density foam to hold the tie and the heat-bent sleeve to protect the contents were later additions. However, the

results were still unsatisfactory. One of the considerations had been to treat the whole package as an object in itself – something you would display.

After all these concepts had been rejected it was a natural process of elimination to decide that injection moulding was the method of manufacture for this item. The original brief to create completely clear packaging allowing the contents to float could now be explored. While injection moulding is very expensive, with tooling charges representing a large proportion of the total cost, it gives you the greatest flexibility to create the desired shape. There are also a number of different base materials that can be used in manufacture, the choice of which is determined by how you wish the packaging to perform. In this instance the packaging needed to be as clear as possible (a high PVC content) and resilient to cracking if dropped (an element of polypropylene).

Armed with this information the designer created an amorphous organic pod, the tie being held on inverted 'nipples' which dripped into the container. The design was slightly modified to make the lid the same as the base enabling them to slot together. This cut the tooling costs significantly.

However, once again the design was rejected by the client. The brief had been to create a packaging solution that was an object in itself, but the client felt that the nipples obscured the design of the tie and, because the injection-moulding process does not allow you to see what the finished result will look like, a 'safer' route needed to be explored.

The original concepts were re-employed, and the routed foam tray was resurrected which would then be inserted into an injection-moulded lift-off lid box. A hole was incorporated in the base of the lid to allow the user to hang the box up when the tie was not in use. The packaging allows for display at retail and in the home. It also offers adequate protection and storage. While the packaging is not regarded as experimental by the designer, its development and manufacture was a journey into the many possibilities with production. The notion of utilising the very heavy industrial production process for the display of art is unique.

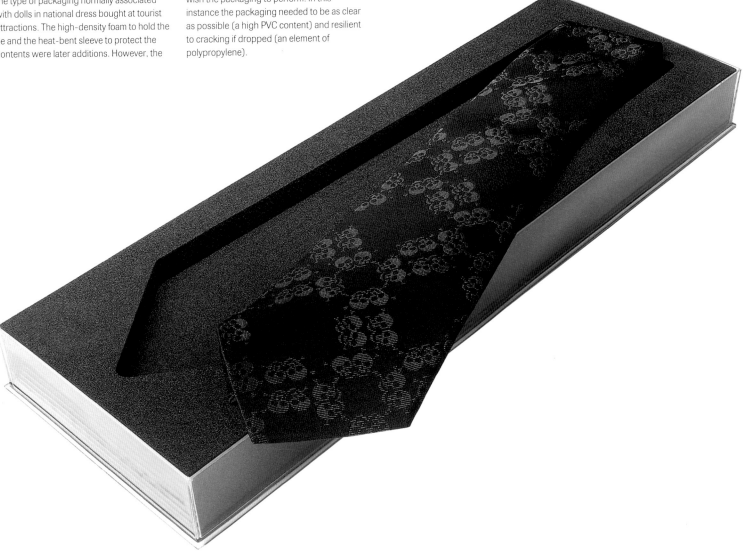

Project	**D&AD Show Reel 2000**
Design	**Frost Design**
Client	**D&AD**
Materials	**High-density foam, white-lined grey board, book cloth**
Origin	**United Kingdom**

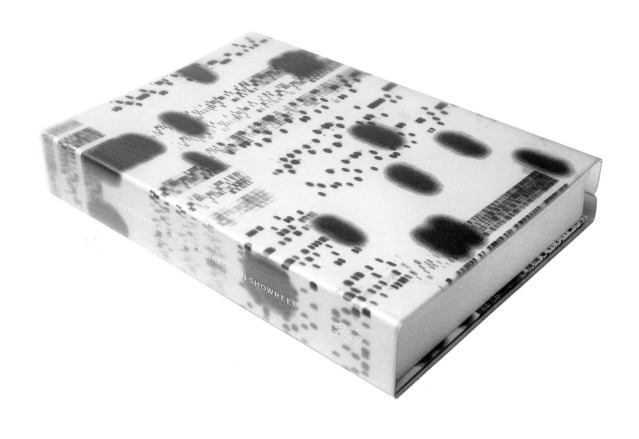

The year 2000 was the year that scientists had virtually finished cracking all the genetic codes for the human race. This event prompted the influences of this packaging. The show reel was a companion piece to the D&AD annual which is published every year and sent out to D&AD board members only. The show reel packaging was proportionally the same and used identical materials to the annual, particularly the cloth binding that was a run-on from the much larger run of the annual. It is a very prestigious opportunity to be asked to design the cover of this annual, a book that is produced of award-winning work across all creative design fields from TV advertisements to record packaging.

The designer was conscious that it was going to a very critical audience and that it was important to create something of value and worth. The show reel's packaging had been ill-considered up until this point and it previously had seemed cheap and of little worth. The packaging now placed it on an equal footing with the printed annual in terms of dimension and bulk.

The quasi-medical theme is extended into the white high-density foam that houses the contents and the natural flexible sleeve that slides over the top which echoes the dust jacket on the printed annual. Due to the fact that the routing process does not allow right-angled corners on the apertures the designer had the small brochure die cut specifically to fit. A yellow pencil icon, the D&AD's award trophy, is rendered as one of the genes – the total designer gene. The design and prototyping took one month with the majority of the book cloth going to a binders in Italy and the balance being used as part of the fabrication of the show reel packaging in the UK. There was no total concept at the inception of the project. The designer merely selected materials and processes that fulfilled the creative concept which were also considered because of the timings that were placed on the project.

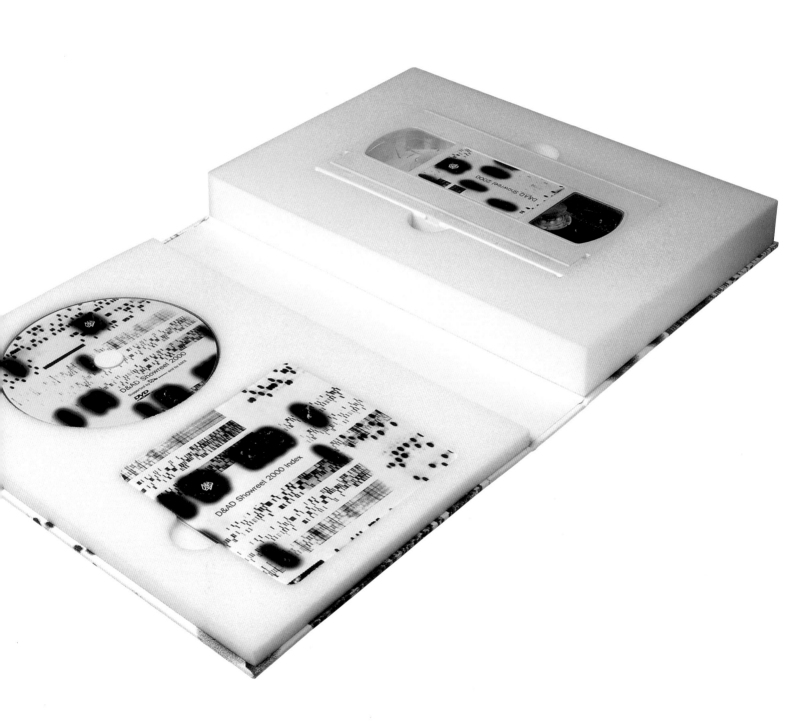

	Project	Nigo Ape Sounds and JL77 Unkle Forces 'Art of War'
	Design	Futura, colour manipulation – Stash
	Client	A Bathing Ape/Nowhere Co.
	Materials	Moulded plastic, corrugated board, gloss clear PVC
	Origin	United Kingdom, United States of America, Japan

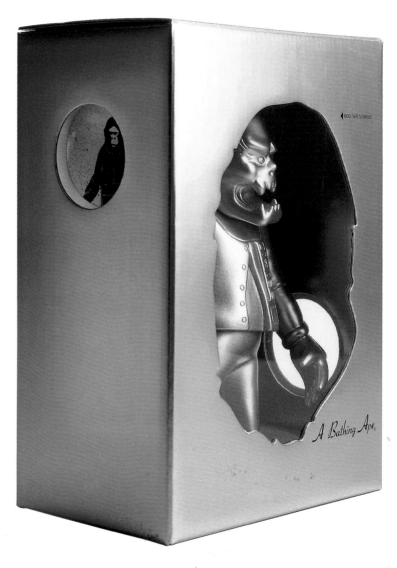

Toys are part of our childhood. The moulded plastic concoctions are viewed in toy shops, the brightly coloured boxes offering an ambient glimpse of the contents. Yet, looking back on those moments it is very easy to remember how sometimes the plastic figure on the inside bore very little resemblance to the activities that were illustrated on the box.

The concept of toys for adults is a logical extension from the recapturing of childhood that collecting model cars creates for some individuals. What distinguishes these examples from the others is that the characters are more nightmarish, the weapons more violent and their contexts more abstract. It also represents a novel way of packaging music and yet, at the same time, builds up an image and history beyond the recordings themselves.

The outer packaging is constructed from corrugated cardboard that has been die cut to reveal the contents. The die-cut shape is a coded reference to the Bathing Ape logo and the text on the reverse part of the language of the world of Futura 2000, the artist who created these figures. These two figures, which have been injection moulded, have taken on near religious significance in recent years as the power and image of the Mowax record label and Bathing Ape clothing brand have increased in the more opinion-forming groups around the globe. Inside each box is a slot for the CD, covers of which are designed by Futura.

The iconic nature of these items is a badge of exclusivity, a code of understanding to the people who consume this lifestyle. Both figures have appeared and re-appeared coloured in different ways, and each time their value increases dramatically. Conceptually there is nothing out of the ordinary in this packaging per se; it is rather more the colouring, the typography and the aggressive way the packaging has been designed – or not designed, as the case may be. The box is similar in construction to a typical toy carton but the use of corrugated cardboard, metallic and khaki green gives a more industrial and military result.

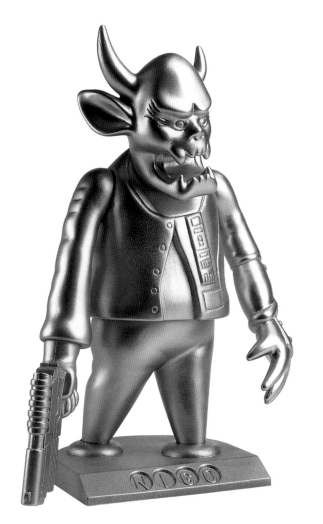

Project	Swell
Design	Nick Crosbie
Client	Inflate
Materials	Dip-moulded PVC
Origin	United Kingdom

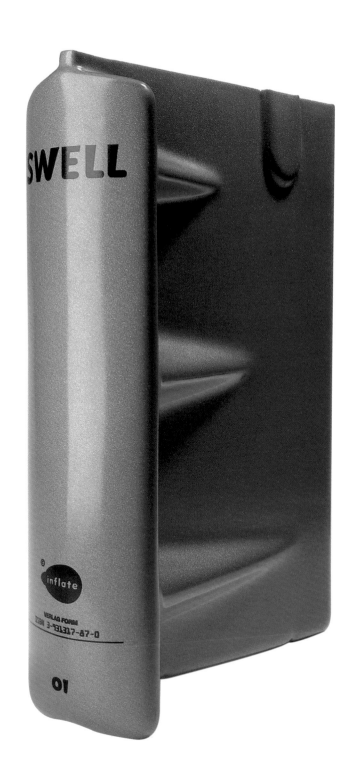

The designer was interested in creating something that would give this perfect-bound book some presence. He was initially keen to retain the thinness of the book, but instead has achieved a large, almost leather-bound, tome-like spine, which has given it an even greater power. It also acts as a book rest when turned 90 degrees to the rest of the books on the shelf.

The run was limited to 2,000 copies with the dip-moulding process being used to create the slip case. It was important to be aware of the process's limitations as well as its possibilities. Cost is ever an issue with unusual processes requiring moulds, and consideration was given to how the material would flow around the mould and how many tools could be put up at any one time to make it more cost-effective. It took eight weeks to produce and the aperture for the book was estimated as no book sample was available. Fortunately it fitted perfectly to the millimetre.

Its manufacturing processes and forms echo several of the products Inflate sell wholesale around the world. It is waxy and squeaky to the touch on the one hand and looks cold and steely on the other. Looking and feeling unlike any form of book slipcase it echoes some very different household products that exist, thereby enhancing the debate as to how a book is packaged.

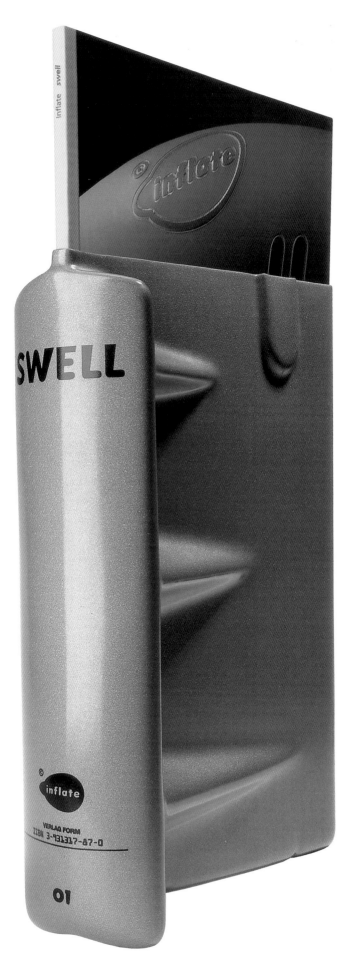

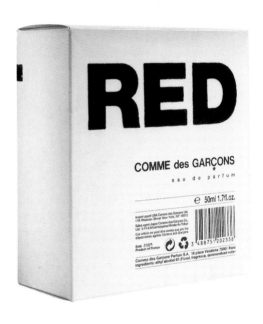

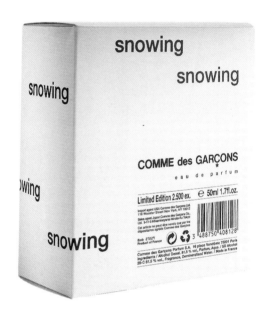

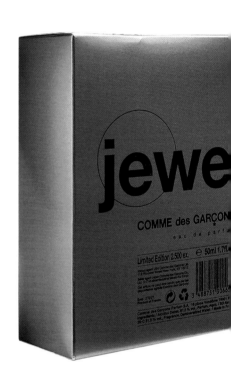

Project:	Red Velvet
Concept :	Comme des Garçons Parfums
Graphics:	Marc Atlan

This, the first limited edition of the perfume, was created in 1995. Taking as its title and theme 'Red Velvet', the cardboard box has the title flocked in blood red, giving the box a very tactile quality to the otherwise stark clinical box. Inside the carton the bottle is vacuum packed within a large sheet of clear polythene, with the title printed across the top. The bottle itself has been totally flocked in the same blood-red colour.

Project:	Snowing
Concept :	Comme des Garçons Parfums
Graphics:	Marc Atlan

Once again the outer box is kept very restrained. The title typographically illustrates the message, working as snow flakes descending down the box. Inside, the bottle is again wrapped inside a large vacuum bag. This time the bottle is painted black with graphic circular snow flakes randomly positioned around the bottle.

Project:	Jewel
Concept :	Comme des Garçons Parfums
Graphics:	Marc Atlan

Two versions of this edition were produced, 'Jewel Circle' and 'Jewel Square'. The outer boxes are both the same with the exception of a keyline of either a square or a circle. Inside, the customary plastic vacuum bag reappears. However, this time the bottle has a structural alteration – the bottle top has been redesigned in the form of either a square or a circle. The bottle itself remains clear to reveal the perfume inside.

Each year Comme des Garçons creates a special numbered limited-edition version of their *eau de parfum* which is released around Christmas time. The original perfume was first launched back in 1994 in the distinctive flat pebble-like flask. With the first limited-edition version released in 1995, to date six limited editions have been produced with the seventh now in production. Each edition works using the existing bottle design but either applies an effect directly onto the bottle, or clothes the bottle in some other manner. The outer packaging of each edition varies each time according to this execution, creating in their words a 'new bottle'.

Comme des Garçons does not see these limited editions as a marketing device to sell the product, but as an extension of the philosophy of Rei Kawakubo, the creator of Comme des Garçons, to always challenge and create something new. To Comme des Garçons perfume is just another way to express the idea. Like clothes or shop interiors, no commercial compromises are made.

Courtesy of the collection of Robert Finnigan.

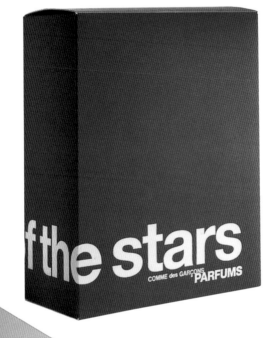

Project:	Christmas Pillow
Concept :	Comme des Garçons Parfums
Graphics:	Marc Atlan

The outer box of this edition is reduced even further to just a clear sticker applied to the white carton, looking more fitting for a pharmacy than a beauty counter. Inside the box the vacuum bag has been dispensed with and the bottle is now shrouded in padded black velvet with a woven label sewn into the seam.

Project:	Merry Xmas
Concept :	Comme des Garçons Parfums
Graphics:	Work in Progress

Although the size of each edition's box varies, the general proportions are fairly similar, until this edition, which adopts a larger flat box. The outer packaging on this edition is more involved than on previous versions. Printed on mirri-board, the outer sheath slides off to reveal the bottle which is counter-sunk into a piece of high-density white foam, covered with mirri-board which is printed with the title written small over the entire surface. The bottle itself has also been chromed, the title left clear to reveal a glimpse of the contents.

Project:	Night of the Stars
Concept :	Comme des Garçons Parfums
Graphics:	Work in Progress

Returning to the standarised box format, inside this edition the bottle is dressed in a fine gauze bag containing hundreds of small gold stars. Like the Christmas Pillow, the bottle shape has been obscured and is only apparent with handling, the stars shifting in your hand to reveal its contents.

Project	Comme des Garçons Parfums	
Design	Marc Atlan, Work in Progress	
Client	Comme des Garçons	
Materials	Polythene, card, mixed media	
Origin	France	

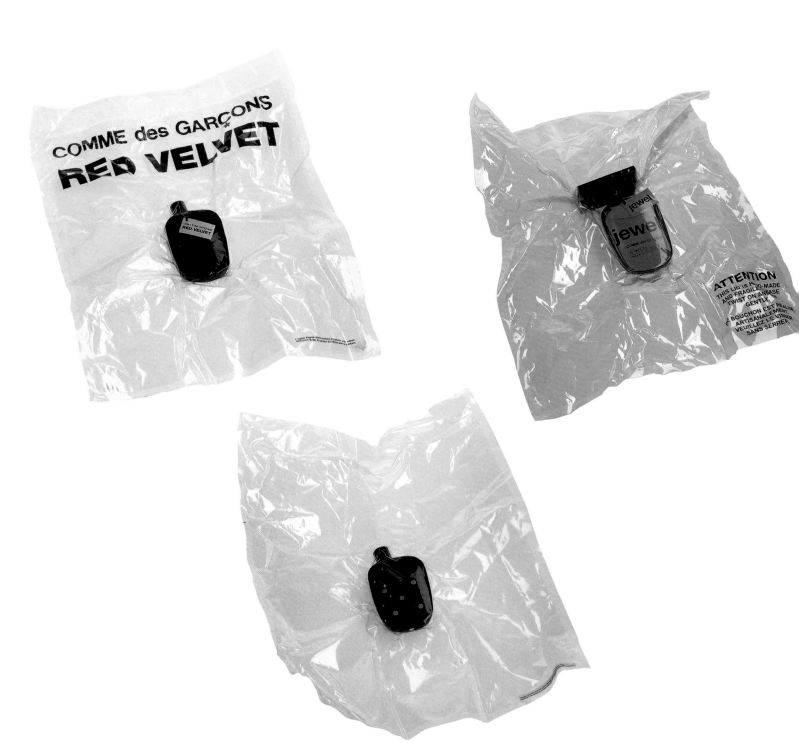

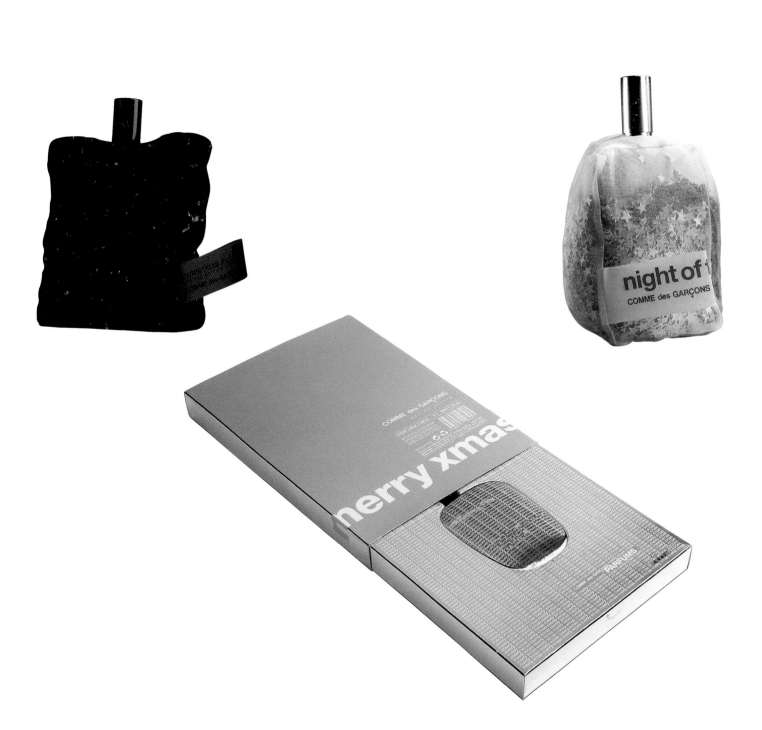

Project	Comme des Garçons Parfums
Design	Marc Atlan, Work in Progress
Client	Comme des Garçons
Materials	Polythene, card, mixed media
Origin	France

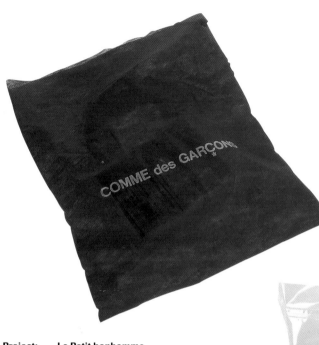

Project:	Le Petit bonhomme
Concept :	Comme des Garçons Parfums
Graphics:	Work in Progress

Though not part of the end-of-year series, these examples show Comme des Garçons' commitment to creating work that transcends the format of perfume packaging. The printed vacuum-sealed bag emphasises the exclusivity of this object by listing the few places from which it is available.

In a sphere of business which is ostensibly marketing-led and normally produced within the remit of a franchise, it is unusual to find a company that has attempted to retain so much control of another facet of a global high-fashion brand. It could be argued that it neither reflects nor detracts from the clothing line it is part of, but represents a philosophy that could exist regardless of the reputation the company's name has garnered for its clothes. The execution has been directly effected by the philosophy of Rei Kawakubo to create objects of contemplation and beauty, and therein lies its experimentation – packaging that does not require needless justification and post-rationalisation. If it did we would know exactly who it was aimed at. We are left with a series of objects that have no relationship to each other, with no common thread other than a logo.

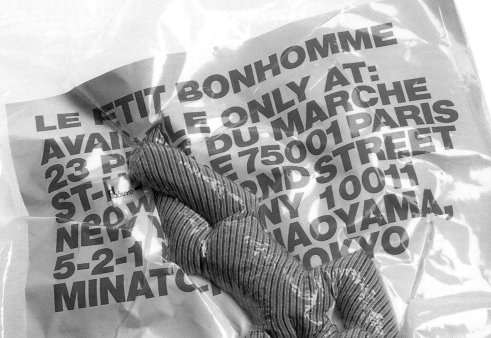

LE P'TIT BONHOMME
AVAILABLE ONLY AT:
23 PLACE DU MARCHE
ST-HONORE 75001 PARIS
520 W BOND STREET
NEW YORK NY 10011
5-2-1 AOYAMA,
MINATOKU TOKYO

PARFUMS
COMME DES GARÇONS PARFUMS

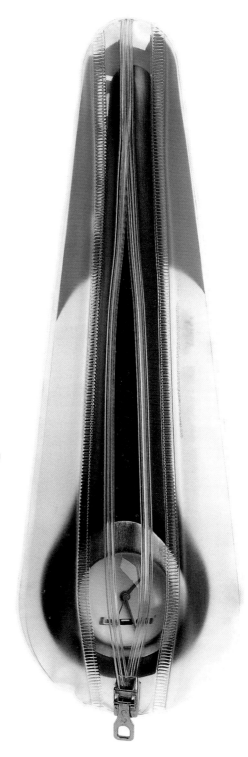

The shape of the watch dictated the overall form of the finished packaging. The watch is simply a moulded panel of foam with a flexible steel rod embedded in it. The end user bends the panel around their wrist to fit, the relationship being like a snake wrapping its body around you. Despite the intended allusion to the packaging being like a snake shedding its skin, the packaging has been compared to a banana skin and, in some cases, a condom.

The run was strictly limited to 500 pieces and budget was very important to the client. The client was still keen, despite this restriction, to make it as design conscious as possible, the watch being aimed at a design-literate, image-conscious consumer aged between 20 and 35.

Initial packaging ideas were to vacuum-seal the watch in a silver-foil bag. This idea was tested but it did not add any value to the watch itself. It was also rejected because the vacuum-sealing process was being too widely used on other lifestyle products at the time and therefore was not original enough.

The packaging ideas evolved to explore other possibilities. Another idea was to make the packaging fit the shape of the watch and for the closure to run along the edge. The high-frequency welding process did not allow this to be made possible, however. Instead, the zip closure, which was welded onto the natural flexible PVC, was placed on the spine of the packaging, a gloss, clear, rigid-PVC, printed instruction panel which protected the foam from damage from the zip. Watches are of a very high value and the client was also very keen to treat the watch and its packaging as an experience which would encourage the consumer into a purchase.

The biomorphic form and the materials that are used are completely removed from any other style of watch packaging. An injection-moulded box with a hinged lid is too functional and appears as if the packaging execution was for expediency and not for creativity. The rigid box route would not be reflective of the watch. The packaging allows you to flex the watch around your wrist without removing it. The watch shape and the debossed logo invite you to interact and be inquisitive about what this product is. The material's frosty touch and appearance partially obscures the time piece but gives a glimpse of the face and foam colour. Another aspect of natural flexible PVC is its approximation in touch to human skin when it has been resting on an illuminated display surface.

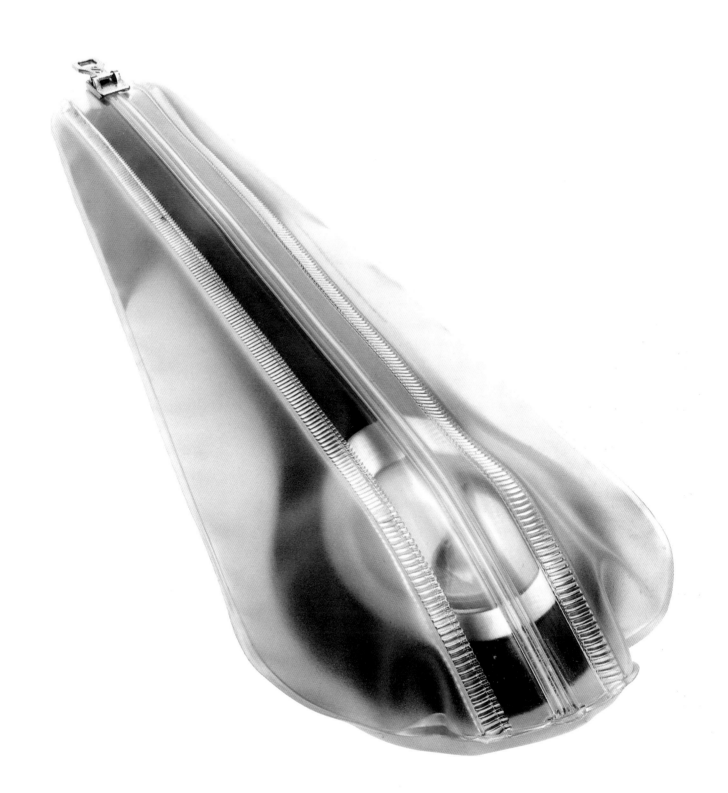

Project	Treasurer Cigarettes
Design	21st Century State-of-the-Art Packaging
Client	The Chancellor Tobacco Co. plc
Materials	Aluminium
Origin	Japan

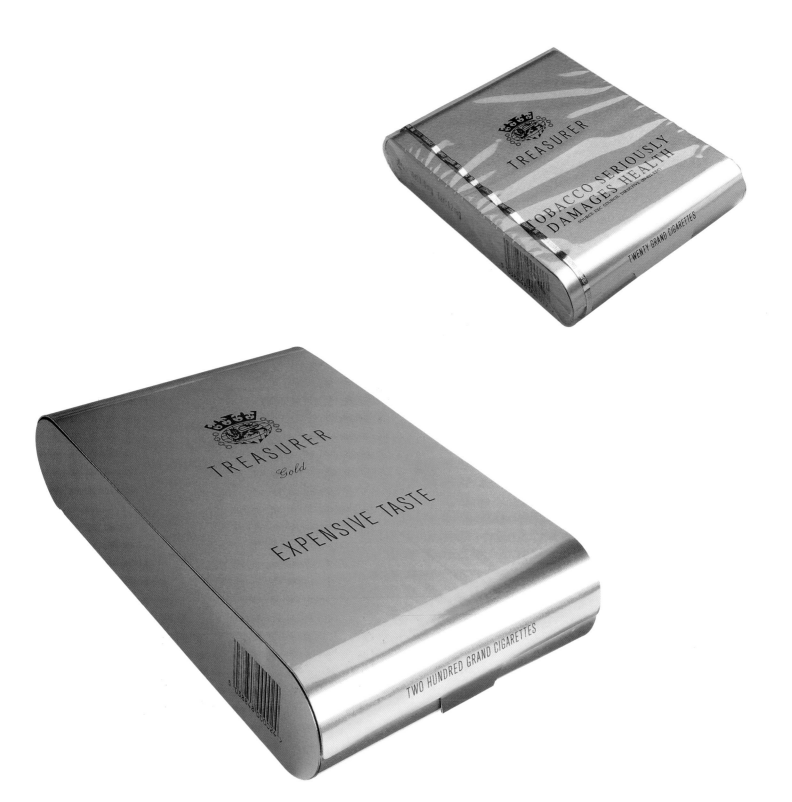

Cigarette packaging, like most retail product packaging, has to be economical and allow for a speed packing process. Yet cigarettes, along with perfume, are luxury products drenched in emotional values and social status. Practically everything has been done to the cardboard used for cigarette packaging. It has been printed, foiled and debossed to the extent that all packaging now appears as a variant of the next brand. The challenge to be different and eye catching is paramount for success. The cigarettes are aimed at a consumer with expensive tastes and for someone who wants a smoking product that sits between the common cigarette and the high-brow cigar.

When cigarettes were first introduced they were specially rolled with the customer's favourite tobacco blends. The packaging was unimportant because the cigarettes would eventually be housed in a precious metal case. This packaging nods more to the direction of these special cases. Gone are the days of decanting your cigarette to a special box. There is no social convention that tells you to. However, this box is all about display.

Although the client still wants to shroud the packaging's influences and manufacture in a partial veil of mystery they have considered how it can be manufactured in volume and transported without damage. The forming tools that need to be fabricated would have taken the longest time but the finished packaging has taken some six to nine months from initial design to first production. From initial trials the feedback from their customers was that they want something from their cigarette packaging that gives recognition and difference. As packaging it is an experiment in creating a brand direction in a market that is prone to criticism on health grounds. The cigarettes are not the first things that come to mind when you hold this packaging. The brushed aluminium finish, the hinged-lid closure, the way the metal has been rolled to create a shape more like jewellery or watch packaging. As cigarette packaging goes it is very ostentatious but its peacock display qualities make it a very tempting purchase if you want to impress your friends or partner.

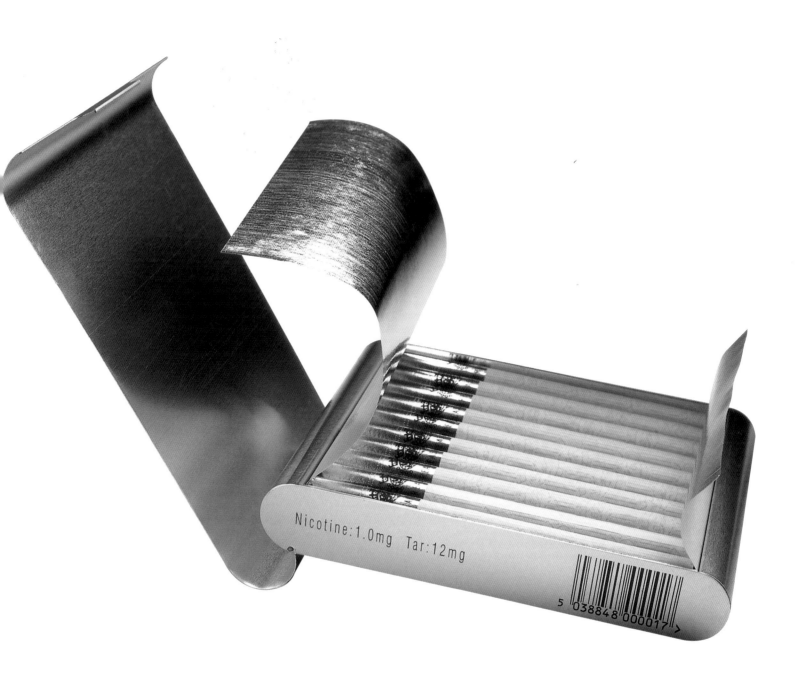

Nicotine:1.0mg Tar:12mg

5 038848 000017

Project	Skin Jewellery™ Packaging
Design	J. Maskrey/Artomatic
Client	J. Maskrey
Materials	Polypropylene
Origin	United Kingdom

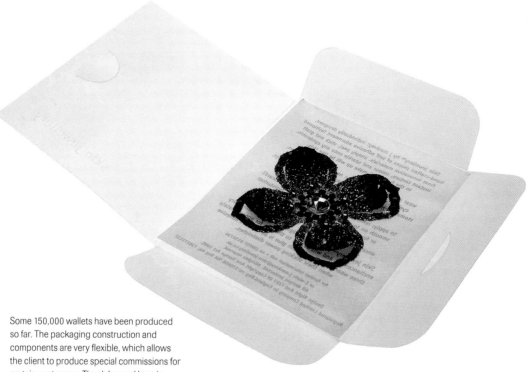

Both Artomatic and the client, J. Maskrey, developed the packaging within a week of their first meeting. The packaging had to appear very modern and be light in weight. It also had to transport and protect the product, and allow it to be seen but not touched. At the time the product was being sold in zip-lock polythene envelopes, the jewellery being stuck onto hand-cut release paper together with a photograph of the product being worn.

All of this existing packaging was stripped back to its raw components. The photograph was removed from the packaging, and the backing paper was replaced with a much whiter release paper with the instructions printed on the reverse in silver. The outer pack was debossed with the company logo. The construction was die-cut and scored out of the lightest weight of polypropylene and kept shut with die-cut tabs. The new packaging solution was cheaper than the existing one, was easy to store and caused less damage to the product. The construction is very much like an artist's portfolio and, as the material does not fold completely flat, has a curved appearance when closed.

Some 150,000 wallets have been produced so far. The packaging construction and components are very flexible, which allows the client to produce special commissions for certain customers. The debossed logo is retained and the company's name is printed over the top. The logo has been through a number of manifestations due to the problems with the debossing. The original logo had a rectangle around it which was also debossed along with the lettering. This proved too much for the material and it distorted and warped very badly. The logo is now the lettering only.

The polypropylene surface texture and its translucency partially obscures the glitter and shimmer of the contents inviting closer attention of what is neither jewellery nor cosmetics. There is also something very utilitarian about this wallet; it has a very portable appeal, is hard and functional, yet the contents are very sumptuous. The packaging is not exactly integrated with the contents but they do interrelate, relying on each other's strengths, one being display, the other being practicality.

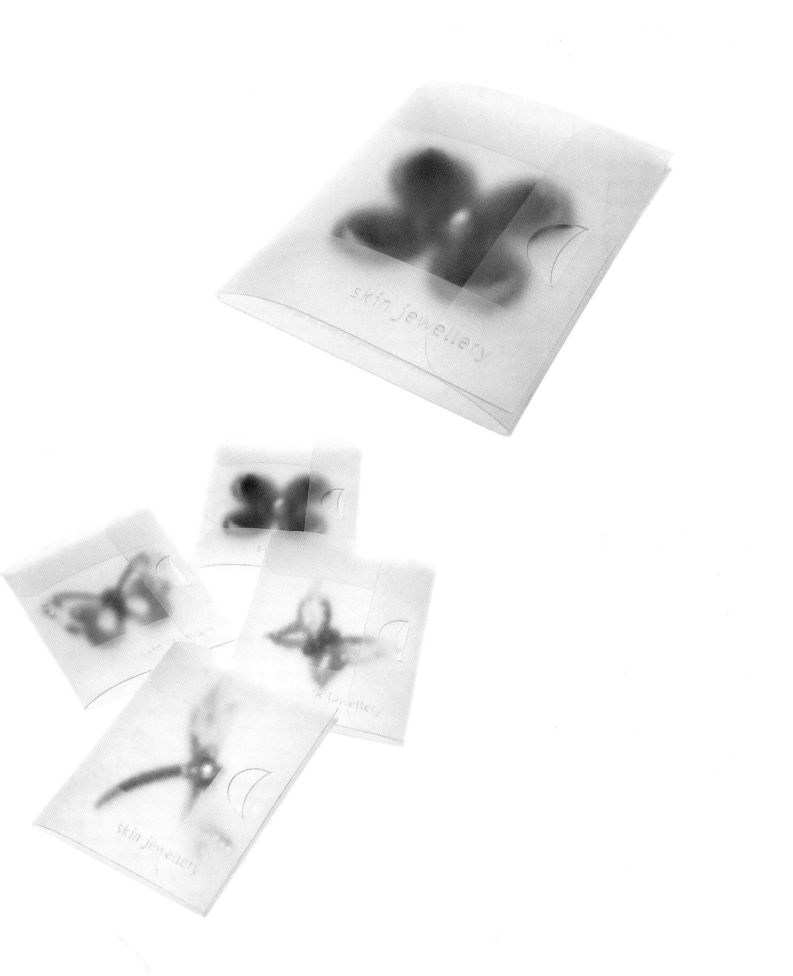

Project	**Gerba**	
Design	**F. Bortolani and E. Righi**	
Client	**Agape**	
Materials	**Corrugated card, EVA, stainless steel**	
Origin	**Italy**	

Packaged in a simple corrugated-card hinged box, this unusual shower gel dispenser is an interesting appropriation of a medical blood transfusion bag for domestic usage. The outer carton is screen printed with a graphic image of the contents. On lifting the lid, the product is positioned within a recessed hole to keep everything flat and as graphic as possible.

The whole piece is produced to the very highest standards, reducing the product to the simplest elements, even down to the functional wall attachment, a simple 'L'-shaped piece of stainless steel which adheres to the wall and from which the bag hangs. The product is very much a luxury consumer item, with a high retail price to match. The transfusion bag is non-refillable, so the whole system has to be replaced. The soap comes in a variety of different colours including orange, green, and blue.

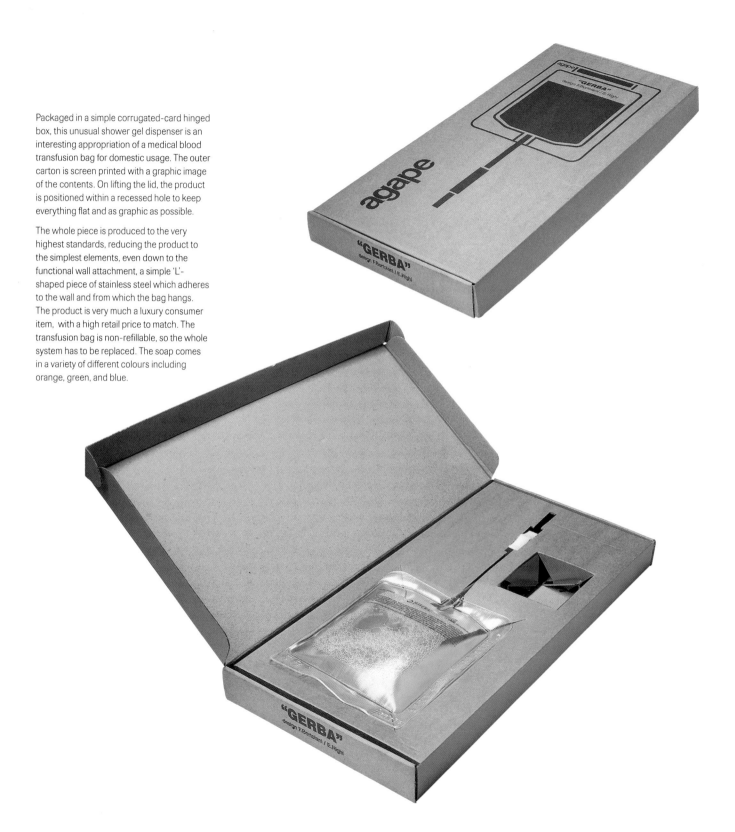

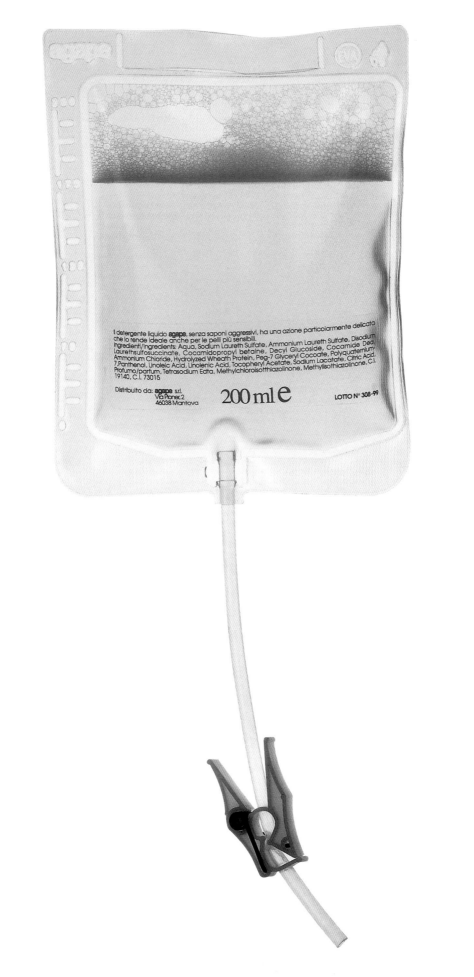

03_Inform

astic. Most of it
e way that light travels
the high speed

tic. Most of it
way that light travels
e high speed

Most of it
y that light travels
high speed

vels

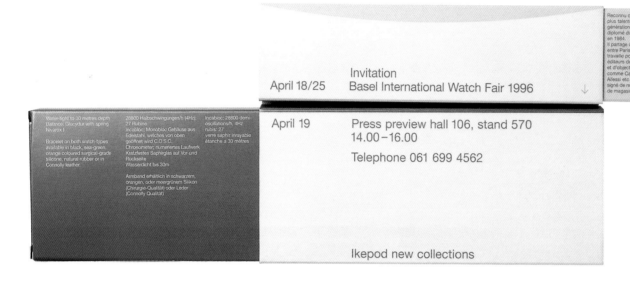

This is not a box. It contains nothing but information and air. Disguised as a package, this invitation was designed to promote an exhibition stand of Marc Newson's Ikepod watches at an international bookfair.

The information, rendered in a style directly influenced by the graphics of 1960s pharmaceutical packaging, appears on every surface of the invitation, encouraging the user to explore and discover every facet of both the sleeve and two trays. The run of 2,000 has been printed on folding matt-laminated boxboard, and was produced within the confines of a very tight budget. A great deal of time has been invested in its engineering which has been fully realised in production.

It looks very simple, yet would have been complicated to assemble. While also being keen that the invitation should work typographically and visually with the three colours selected for printing, the designer sought to implement some surprises. The invitation appears to hinge in the middle, but actually opens only slightly. The way the dates straddle this divide is a cunning graphic conceit that also splits the title of the fair along with the name of the invitee. This split is further extended to the two trays when they are both pulled out to reveal the internal information. You do not feel empowered to destroy the invitation to get at the information, rather to read its contents in stages.

Invitation
Basel International Watch Fair 1996

Chronographes Hemipode
Chronographes Rattrapante Hemipode

April 18/25

April 19

Press preview hall 106, stand 570
14.00–16.00

Telephone 061 699 4562

Ikepod new collections

Project	Office Orchestra
Design	Andrea Chappell and Cherry Goddard
Client	Makingspace Publishers
Materials	Tin, cardboard tubing, cardboard, stationery materials, paper
Origin	United Kingdom

The fundamental concept of an orchestra is a group of musicians, playing a wide variety of instruments, positioned around a conductor. While this is easy to achieve in a concert hall the practical consideration of achieving this, or at least the instruments needed to play music, in the much smaller space of a box is far more difficult. For this 'office orchestra' packaging exploration the cardboard tube in which the music and instruments were housed could be used as an amplifier or a musical instrument in its own right.

The packaging is integral to the contents, both protecting and housing them. Its design and construction was very much influenced by the materials that could be sourced. The lids are from a different manufacturer to the tube, and the 'instruments' were crafted from existing ready-made stationery products found in any office.

It is very easy to understand the function of all the components when playing the music. The circular concertina effect that you first see on removing the lid allows you to glimpse only part of the whole this packaging has created. The contents are very ordinary, and not displayed by the packaging in the ostentatious manner of perfume packaging, for example. So often with artists' books or multiples the packaging is very parochial so as not to clash with the message that it is trying to convey. This is true in the case of the office orchestra, but the plain labelling has a Pandora's Box-like attraction to the user inviting further exploration.

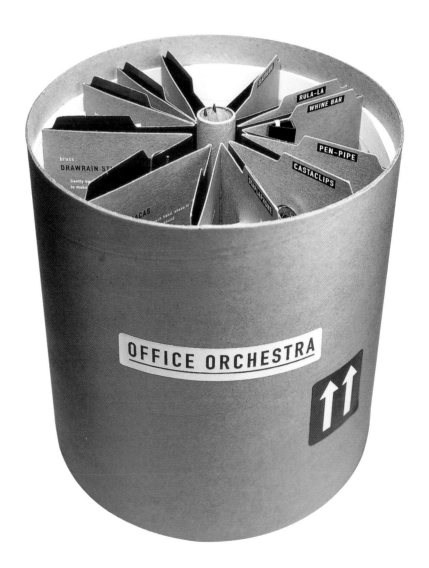

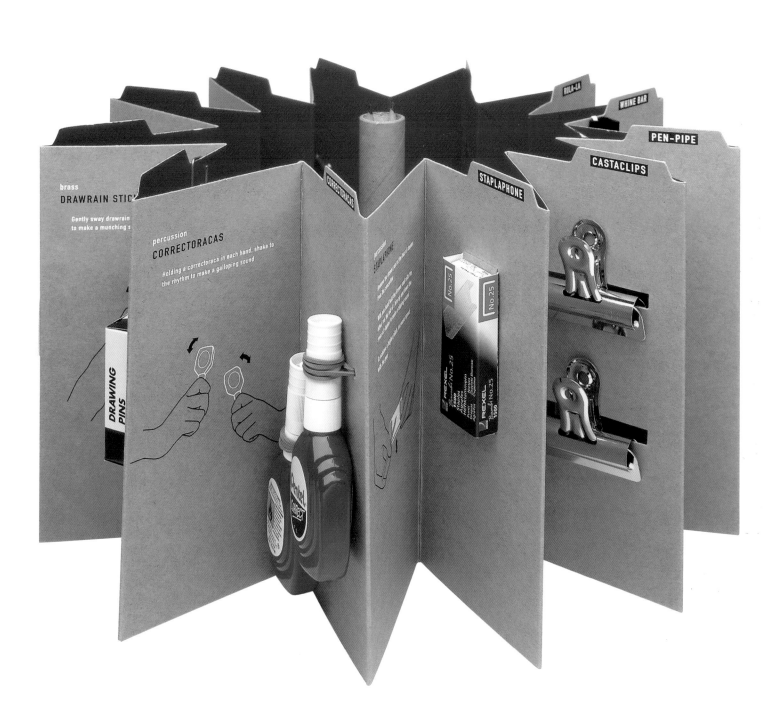

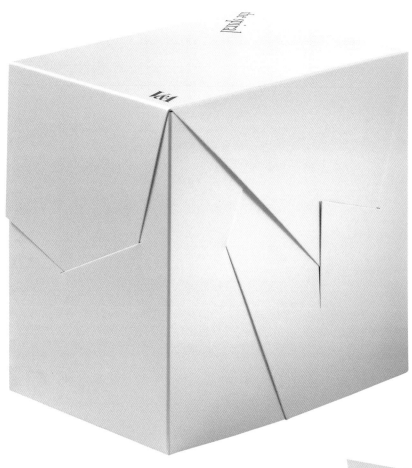

The principle influence on the V&A Box was the proposed V&A building extension designed by the German architect, Daniel Libeskind. Aimed principally at wealthy potential donors this project started off as a two-dimensional A4 brochure. It was felt by the designers that it did not do the extension justice and that the information should be presented in three dimensions. Working in three dimensions was also something that the designers had wished to do for some time.

Its fun, interactive quality was also designed to make the end user want to keep it, although it is to be kept for other reasons. The architecture for the extension is very radical and therefore the 'brochure' needed to encourage the viewer to examine and debate its structure and its meaning.

The printed information is almost secondary in this regard. Only a couple of experiments were completed and one finished concept was presented, which took about four months to design and produce. It is very tempting to break the whole thing apart and analyse its construction. The choice of white board (the building will be this colour) gives the whole construction a very hard finish, yet it is light in weight, almost without substance. The designer still looks at this project as a brochure which just happened to end up in three dimensions.

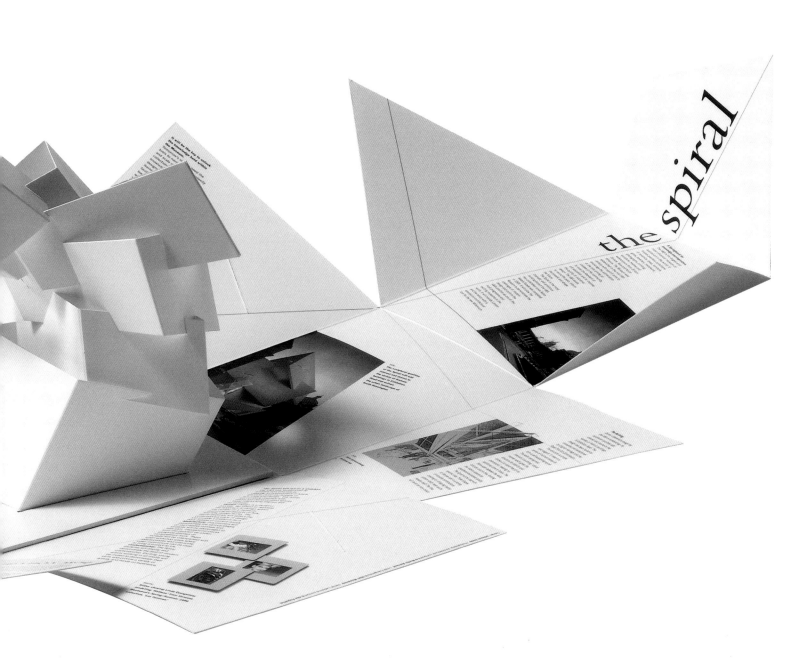

Project	Box Product
Design	Odg/Otto Design Group
Client	Phil Otto
Materials	Baltic birch plywood, plastic laminate, powder-coated steel
Origin	United States of America

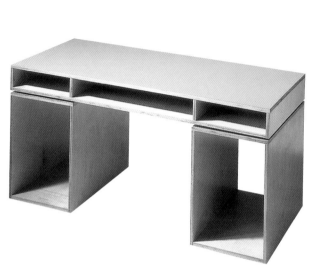

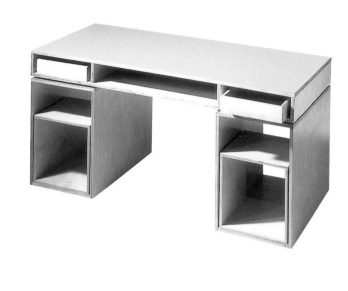

Odg/Otto Design Group are a US-based architecture and interior design firm with offices in Philadelphia and Los Angeles. Working for a diverse client-base they create imaginative retail interiors with unusual uses of materials and processes. Their founder, Phil Otto, has a broad interest in all aspects of design and applies his broad knowledge when approaching projects.

The designer's oldest brother is a mathematician and computer language expert – the eternal student. For years he has watched him live out of boxes, his only possessions being books and computer equipment. These cardboard boxes always ended up being used as furniture, augmented occasionally by a few folding chairs.

In a bid to improve his brother's lifestyle it seemed a logical step to build better boxes for him rather than attempt to change what was a simple and comfortable furniture, storage and packaging solution. The designer's execution for this scheme was then augmented by a skateboard culture aesthetic while also borrowing from the do-it-yourself tradition.

Plywood has been used a great deal so far for its utility more than its placement either ahead or behind material trends. Laminate is used in a utilitarian manner to protect certain surfaces. Some powder-coated metal boxes are planned for future production and further elements in different materials and colours can also be added seasonally to suit fashion and taste.

The Box Product range's dimensions adhere to a set of standards in order to allow for a maximum amount of interchangeability in usage. It is a set of elements intended to provide a minimum of structure for the owner's artefacts and way of working.

As furniture it may seem cold and uninviting, but one cannot escape from the notion that this is the most practical method of packaging our possessions. It is a rigidly abstract method of looking at both furniture and packaging – stripping away any unnecessary elements as it allows for no decoration. It is up to the end user to provide ornaments and books from their lives to decorate it. For the designer's brother it is a no-fuss method allowing him to continue to live his life how he wants to.

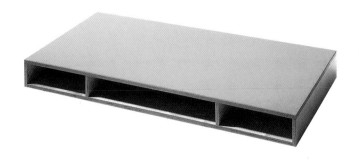

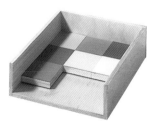

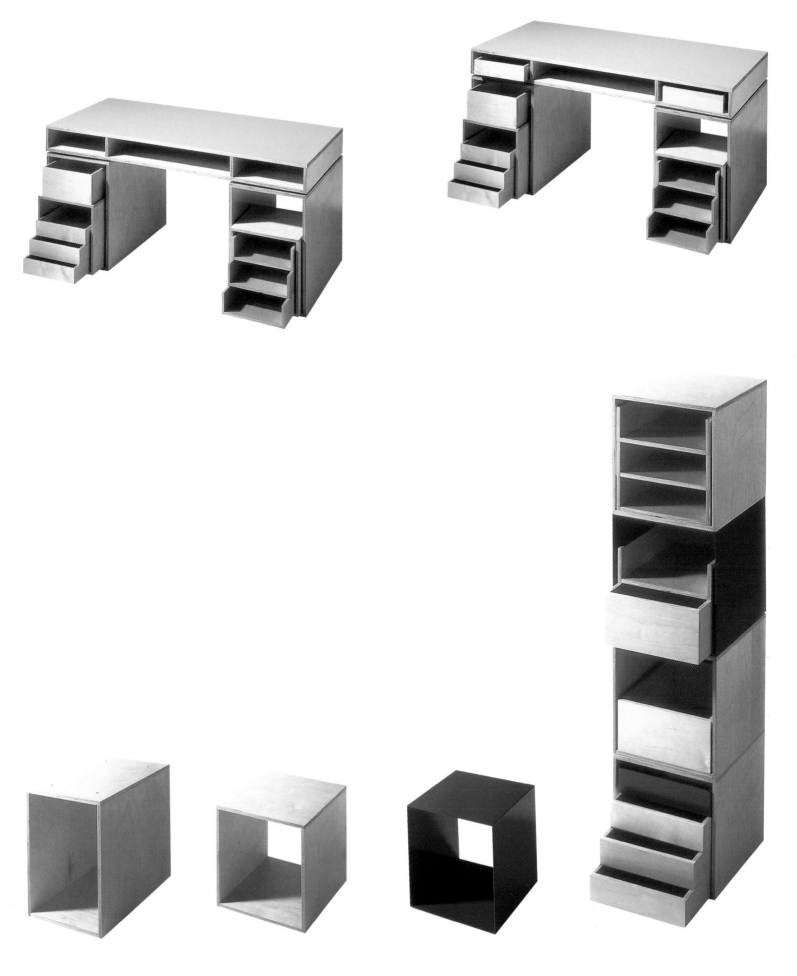

Project	at.mo.sphere Floppy Disk/MO Disk Packaging
Client	Abahouse International Co. Ltd.
Producer	Yasiyuki Kimura (Abahouse International Co. Ltd)
Co-ordinator	Toru Hachiga (+81 Magazine)
Design/art direction	Hideki Inaba
Materials	Grey board, folding boxboard, matt-art paper, tracing paper
Origin	Japan

I wonder what joy is in r

The philosophical sentiments behind this piece of packaging belie its execution and materials. The sphere is a central point around which all ideas revolve. The designer was keen to instill this idea of creative energy into something as simple as the floppy disc. He was attempting to empower the end user to aspire to creative feelings, the hope being that the discs would serve as their notebook of exploration. The thinness of the discs was not meant to be visible on the outside of the box. The paper-over-board hinged-lid box was meant to appear heavy, the bright orange and coloured discs thus appearing more delicate when opened.

As a rigid box the construction is beautiful, a trait which is common to the majority of packaging produced in Japan. There are no fundamental differences to the manufacturing processes that are employed in this packaging to that of the West. There seems to be a greater attention to detail which is afforded to Japanese manufacture that we do not have the luxury of achieving due to cost and timings. As a product this accompanies a wide range of hardware, once again elegantly manufactured. As the desire to integrate computer technology into the home gathers momentum, making it sit more comfortably with our other belongings, so this disc packaging adds to the comforting feeling its sentiments represent.

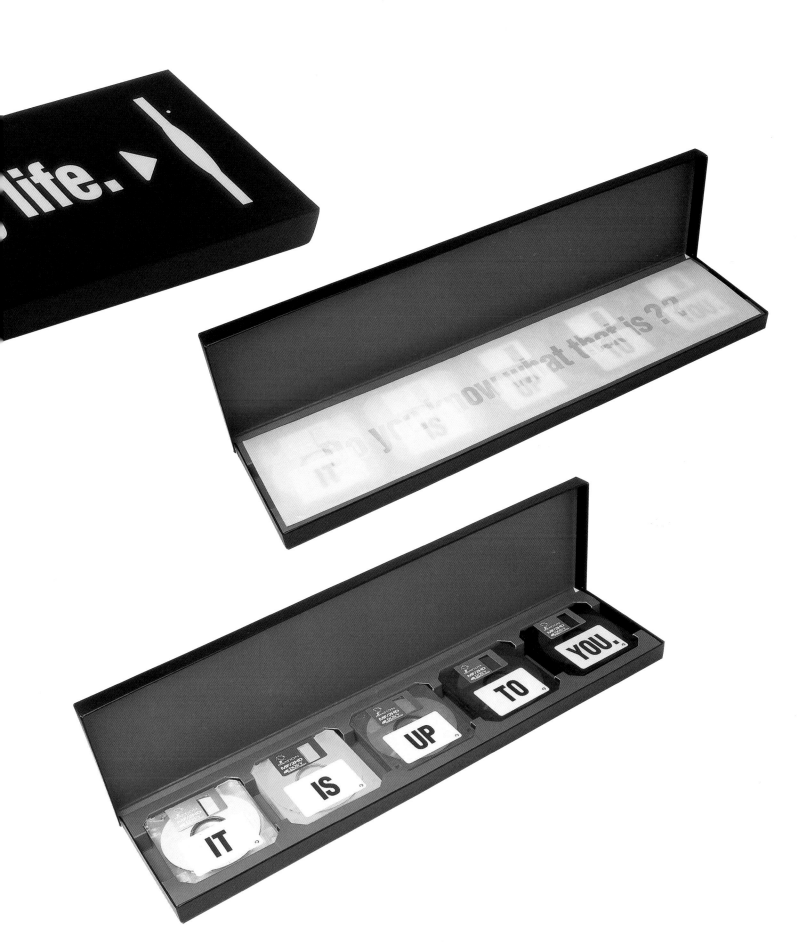

Project	Superga shoe box
Design	Pentagram
Client	Superga
Materials	Card, rubber, press stud
Origin	United Kingdom

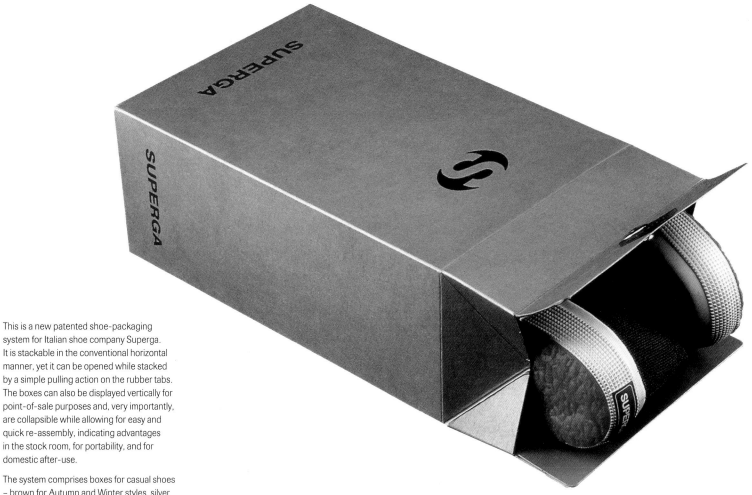

This is a new patented shoe-packaging system for Italian shoe company Superga. It is stackable in the conventional horizontal manner, yet it can be opened while stacked by a simple pulling action on the rubber tabs. The boxes can also be displayed vertically for point-of-sale purposes and, very importantly, are collapsible while allowing for easy and quick re-assembly, indicating advantages in the stock room, for portability, and for domestic after-use.

The system comprises boxes for casual shoes – brown for Autumn and Winter styles, silver for Spring and Summer – and sports shoes – blue for Autumn and Winter and red for Spring and Summer.

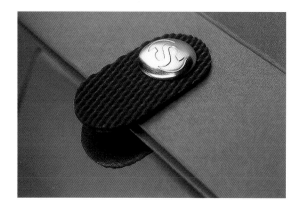

Project	Remarkable Pencil Packaging
Design	Frost Design
Client	Remarkable
Materials	Dutch grey board
Origin	United Kingdom

As outlined previously, a commonly held opinion is that sometimes packaging or, more precisely over-packaging, is unnecessary and causes an unwanted drain on the earth's resources. It is not only the material waste but also the unnecessary waste of energy required to glue and manufacture a product that can cause some offence.

Remarkable recycled pencils are part of a much larger stationery range that is fabricated from recycled waste (pens made from milk cartons for example). The pencil is made from recycled vending cups (one in each pencil) and contains no wood. The client had stressed that he wanted the product to be regarded as a good pencil first, above all the environmental concerns. The designer was also motivated by the concept of the product and the fact that everything was well made.

The energy-saving aspect of the packaging is that it is all held together by one of the pencils. There is no gluing, plus there is the added bonus of seeing one of the pencils on display. The board used to make the packaging has been screen-printed on grey board, itself a recycled board material. It is very compact and can display in a variety of ways which means packaging variants do not have to be manufactured to satisfy the demands of different retailers.

The Remarkable logo came about as a direct result of the client's problems in registering the complete word, as it had already been registered. The designer drew on his first experiences of seeing the product – one of exclamation – hence the shape of the logo. Secondly he chose to allude to the recycled nature of the product.

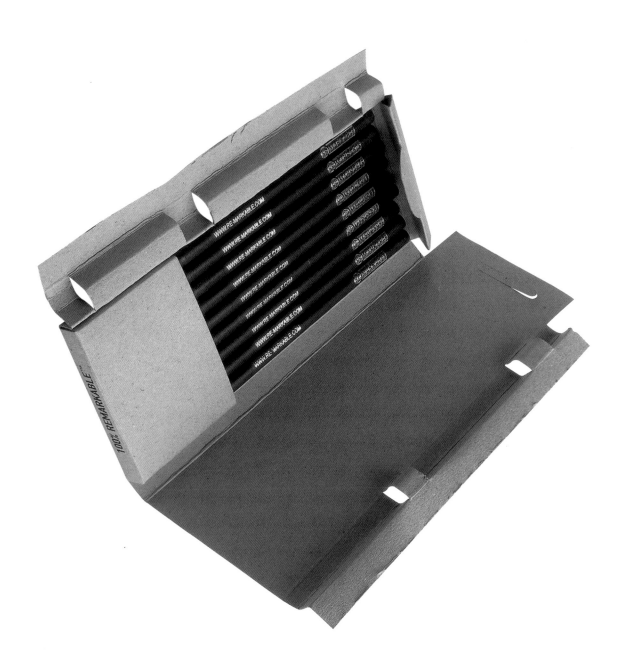

Project	NATO packaging
Design	:zoviet*france:
Client	:zoviet*france:
Materials	Plastic
Origin	United Kingdom

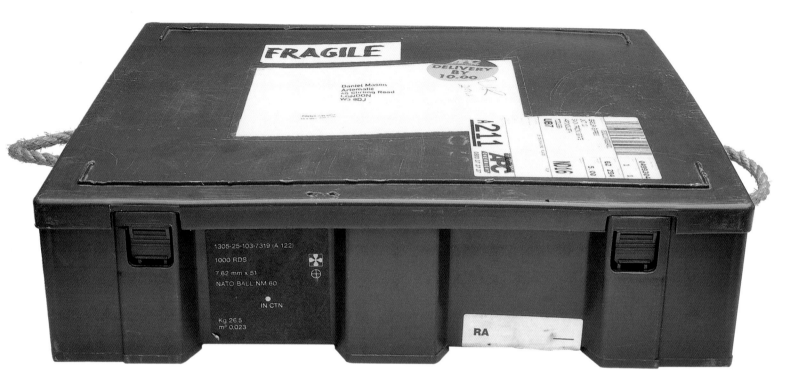

:zoviet*france: is a recording, performance and research music group based in Newcastle-upon-Tyne in the UK. Their music, which is non-song based, is derived from a mixture of acoustic and electronic instruments. Though wilfully obscure, their music has an international audience and they have released a number of records in their 20-year existence. They have recently been writing sound tracks for a number of international dance groups. Their collaboration with other musicians reads like a *Who's Who* of contemporary music.

Their packaging has, however, taken on a legendary status and is packaging that all music performers and designers for the music industry should aspire to in terms of innovation, materials and processes. It is very difficult to summarise and explain all the pieces. However, an attempt will be made here to catalogue their output which arrived to be photographed in a Nato specification ammunition box.

It has always been their objective to take control of as much of the production process of releasing a record as possible. Making the packaging by hand seemed to be the most logical step in achieving this goal and it seemed to them that this act released them from their perceived notion of what sleeve design should be. What was predominantly a graphic format could be re-orientated to establish a different emphasis, physical presence and tangibility.

There had always been an economic consideration in that the cost to produce these sleeves could not affect the retail price of the records. The choice was made to use cheap and readily available materials that could be purchased quickly. They also examined what was physically possible to distribute, therefore use of such materials as ice and slate was rejected.

Each sleeve normally takes two to three months to produce including the experimentation, finalising the concept, sourcing materials and putting all the components together.

A number of feathers were required for the packaging of the cassette release of *Popular Soviet Songs* and *Youth Music* and these had to be sought. It was identified that the Cumbrian coastline, with its high seabird population, would provide the biggest source. They ended up collecting feathers from the beach at Seascale, one mile from the nuclear power station, Sellafield, and only a year after the beach had been reopened to the general public following one of their bigger radiation leaks. Many copies of this album were exported to America, meaning that they were essentially exporting unlicensed low-grade nuclear waste to the land of the free.

The CD release of the same title incorporated discs of felt cut from surplus Red Army caps; the large number that was available has always remained a point of mystery for the group.

Of solutions that were rejected the list contains a number of incidents. They were very surprised at how Red Rhino Records, their record label at the time, was excited about the notion of encasing the records in

ice. As soon as the idea was mentioned the company were looking into the availability of water-tight sealable plastic bags and refrigerated air to ship to the US. The stumbling block proved to be the record retailer's reluctance to provide refrigerators in-store. Following that, the group looked at packaging CDs in polythene bags containing sand. The effect sand would have on a CD was duly tested by the record company, whose owner blew up his CD player at home and never told his family the reason.

Packaging that makes it into production ceases to be experimental for the group. By the same token if it works then it's not experimental. The experimentation happens prior to the final result.

The single motivating factor in all of this has been the British Punk Rock attitude of seizing the means of production and making your own records.

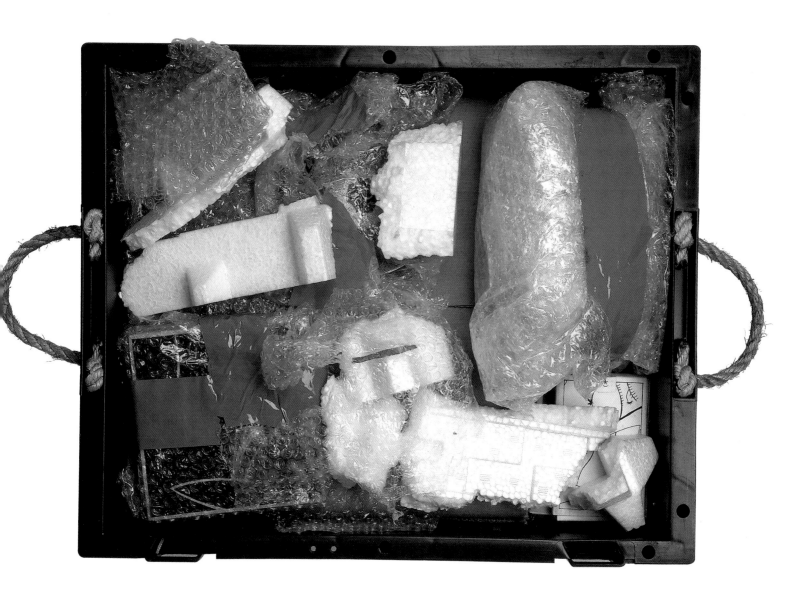

Project	untitled (hessian) (12" vinyl)
Design	:zoviet*france:
Client	:zoviet*france:, Red Rhino Records
Materials	Sheets of hessian cloth, screen printed, cut, machine sewn
Origin	United Kingdom

Project	Norsch (12" vinyl)
Design	:zoviet*france:
Client	:zoviet*france:, Red Rhino Records
Materials	Rolls of aluminium foil cut to size, individually embossed on a litho press, then spray-painted; screen-printed card insert
Origin	United Kingdom

Project	Mohnomishe (2x12" vinyl)
Design	:zoviet*france:
Client	:zoviet*france:, Red Rhino Records
Materials	Sheets of hardboard cut to size, screen printed, drilled, fastened together with hand-dyed twine
Origin	United Kingdom

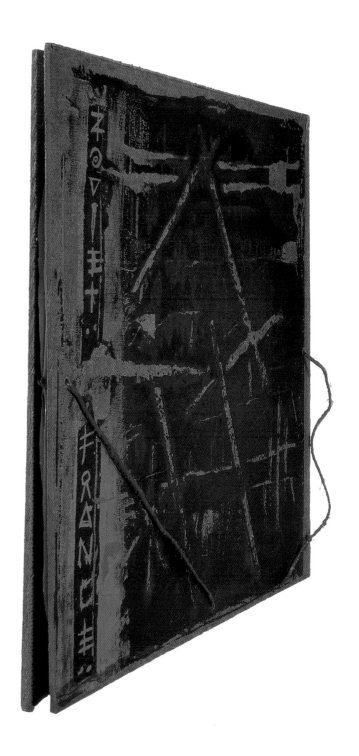

Project	Eostre (2x12" vinyl)
Design	:zoviet*france:
Client	:zoviet*france:, Red Rhino Records
Materials	A0 sheets of acid-free tissue paper, screen printed, folded to size; white pvc screen-printed insert
Origin	United Kingdom

Project	Digilogue (12" vinyl)
Design	:zoviet*france:
Client	:zoviet*france:, Red Rhino Records
Materials	Banana paper wrapper in clear PVC sleeve
Origin	United Kingdom

Project	Gris (10" vinyl)
Design	:zoviet*france:
Client	:zoviet*france:, Red Rhino Records
Materials	Rolls of green chip roofing felt cut to size, painted with four-colour stencil image
Origin	United Kingdom

	Project	Popular Soviet Songs and Youth Music (2xcassettes)
	Design	:zoviet*france:
	Client	:zoviet*france:, Red Rhino Records
	Materials	Slip-cast, clear-glazed ceramic box; hand-painted stick attached to box by twine; seagull feather inserted through holes in box, fixed with sealing wax; screen-printed insert; commercially printed insert; screen-printed muslin flag
	Origin	United Kingdom

INSTRUCTIONS
Do not remove feather.

INSTRUCTIONS
Remove feather by melting wax seal.
Discard burnt cassettes. Retain box.

INSTRUCTIONS
Remove feather by pulling sharply.
Remove cassettes. Suspend box by
string. Strike rhythmically with stick.

INSTRUCTIONS
Grasp stick in fist. Strike side of box
firmly with end of stick. Discard pieces
of box and retain feather. Implement
cassettes.

INSTRUCTIONS
Remove feather and cassettes.
Discard. Blow gently through notch
in box. Discern pitch.

INSTRUCTIONS
Remove feather and retain. Implement
cassettes. Present feather with left
hand. Hold open end of box against
right ear.

INSTRUCTIONS
Look. Listen. Touch. Taste. Smell.

INSTRUCTIONS
Remove feather and cassettes.
Store carefully. Attach 1m piece
of string through holes in box.
Whirl around head.

INSTRUCTIONS
Interpret. Innovate. Implement.

INSTRUCTIONS
Animate cassettes by stroking
with feather. If no movement occurs,
poke with stick.

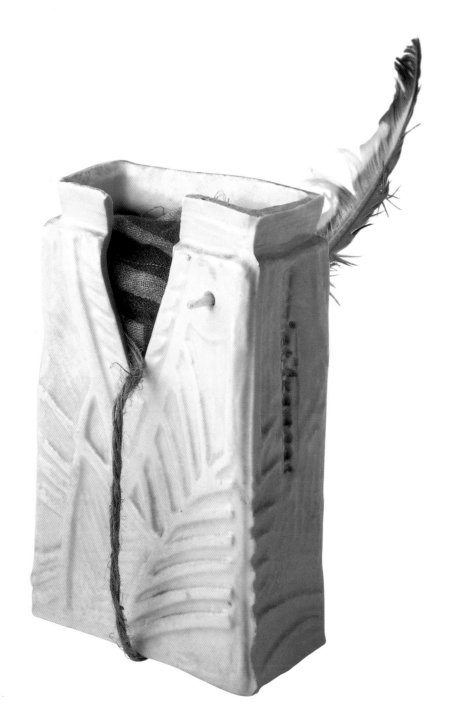

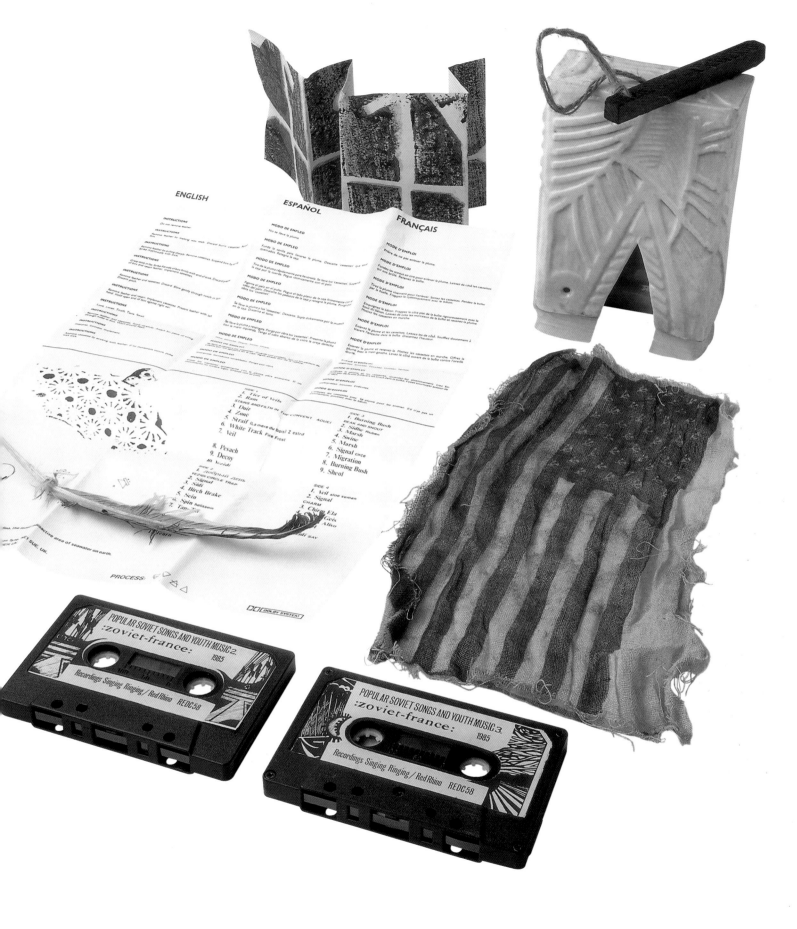

Project	Feeback (CD)		Project	Just An Illusion (CD)
Design	:zoviet*france:		Design	:zoviet*france:
Client	:zoviet*france:, Staalplaat		Client	:zoviet*france:, Staalplaat
Materials	Card, metal butterfly clip		Materials	Custom-manufactured and -printed cigar box
Origin	United Kingdom		Origin	United Kingdom

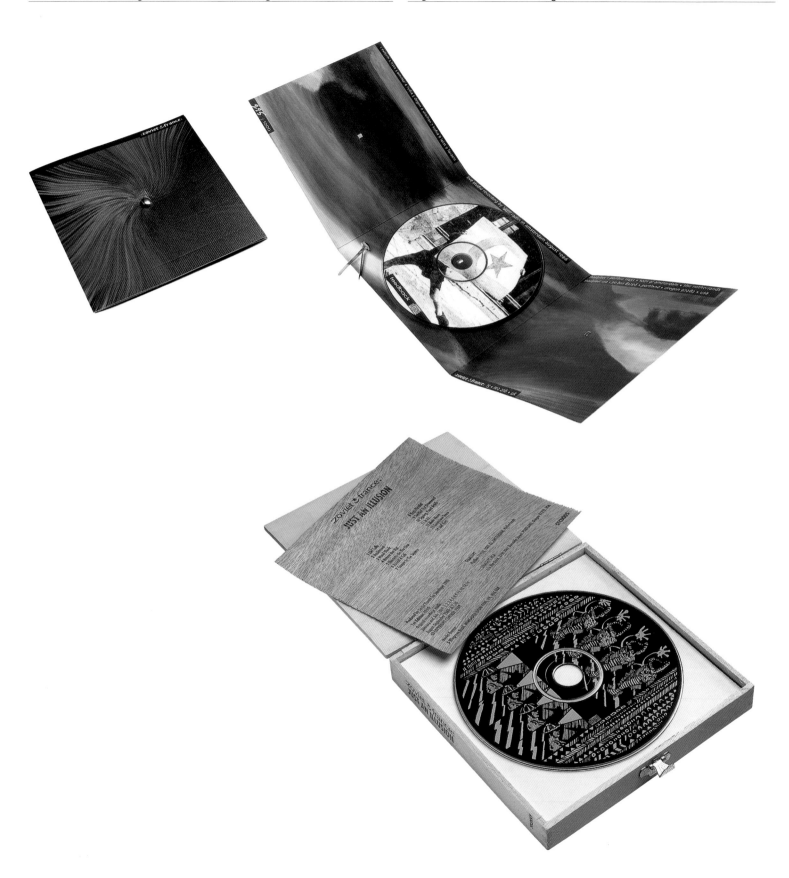

Project	Popular Soviet Songs and Youth Music (3xCD)
Design	:zoviet*france:
Client	:zoviet*france:, Red Rhino Records
Materials	Sandwich of compact discs: blank compact discs dressed with coloured and printed flock; discs of grey felt cut from Red Army surplus caps, fixed through centre hole with Red Army badge
Origin	United Kingdom

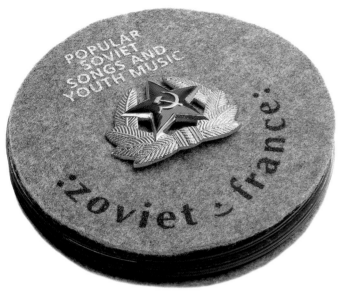

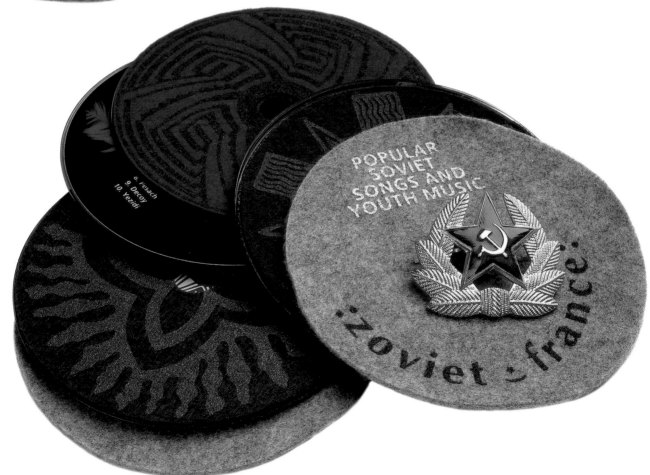

Project	**Curiosity Killed the Ape**
The package:	
Concept	**Keigo Oyamada**
Designer	**Masakazu Kitayama (Help!)**
The book:	
Written by	**Woody Kawakatsu (based on experiences with Keigo Oyamada)**
Thanks to	**Keigo Oyamada, Farah Frayeh Yazawa, Shane Woolman**
Materials	**Card, plastic, soft PVC**
Origin	**Japan**

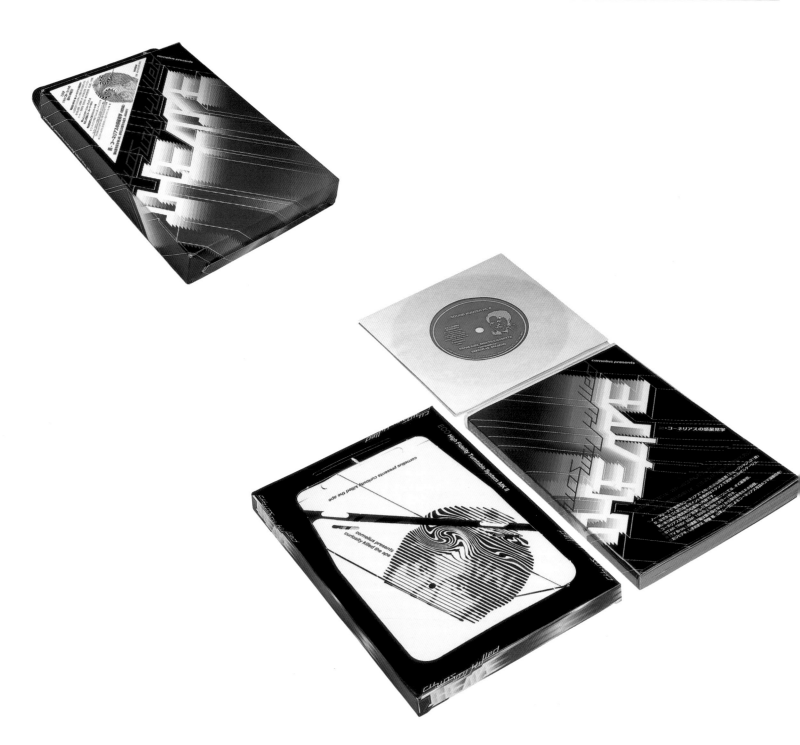

Cornelius is named after the simian hero of the film *Planet of the Apes*. The actor who played Cornelius, Keigo Oyamada, enjoys pop star/heroic status in his native Japan through his music, record label and his views on all aspects of popular culture.

On a recent tour the entire audience comprised of Cornelius clones. The experience was further heightened by the opportunity for the audience to purchase a catalogue containing three-dimensional glasses to watch the music being played in the text of the book. This was augmented by local radio stations playing further rhythm tracks. Cornelius uses no pre-recorded or borrowed samples in his work. He prefers to meticulously recreate them himself. His recorded product and its packaging is

eagerly collected both in Japan and abroad. The record player is only one of his many creative ideas and executions.

The packaging, in this case, is influenced by the magazines purchased on a monthly basis by school children. The magazines, or kits, contain pop-up characters and other items. One kit contains a record player that Cornelius subsequently appropriated. There is also a book that accompanies the discs and player, which contains a collection of interviews and articles about interesting places that he has been to and the people he has met. The recordings on the discs relate to these experiences.

The end result, of which this is one of 10,000, took six months to realise. The package is not

overly complicated but it is, at the same time, staggeringly ingenious. There is nothing complex or clever about the choice of materials. They have been selected for their functionality and, presumably, for their close approximation to the materials that have been utilised on its influences. The elements are all punched out of the box which houses the discs. There are basic instructions to help you and fortunately there is an article in the book with Cornelius demonstrating how it is put together, along with some telling facial expressions as to how difficult it is to complete on the first try. It has all the attributes that one commonly associates with a promotional box that record companies create in small numbers prior to an album's release. It is amazing so many were produced.

Courtesy of Oliver Payne.

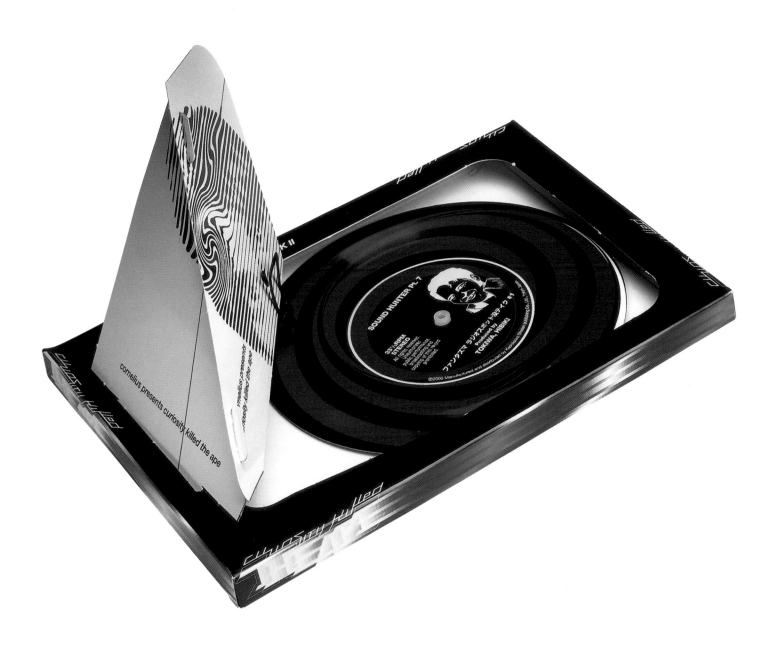

04_Materials

Air-bag

This packaging suspends the contents in the centre of the bag and surrounds them with a protective barrier of air to provide protection during shipping and storage. The contents are placed inside the bag and it is inflated with a pump or your own breath. It is specifically used to ship fragile machine parts but has been appropriated, in recent years, for presentation purposes, providing an alternative to the box.

Anti-static materials

Anti-static materials are used to make bags and pouches when there is a need to counteract the damaging effects of static charges on the contents. The material was originally used to protect gun powder which had a propensity to ignite when exposed to static. Nowadays it is more commonly used to shield circuit boards and computer chips. The most common anti-static materials are:

ANTI-STATIC – These bags are normally translucent-pink in colour, principally for identification purposes. They have one layer of film and an anti-static dissipative layer. They discharge static away from the contents but do not shield them. The charge is merely allowed to pass through the bag.

STATIC SHIELDING CONTROL – The semi-translucent colour is achieved through three or four layers of aluminium film. This metalicised bag discharges static and shields the contents. Originally nickel was used in place of aluminium.

CONDUCTIVE – These are normally black in colour with a single layer that is carbon loaded, hence the matt-black finish. The bag shields and discharges the static quickly but can damage the item inside.

STATIC DISSIPATIVE – Clear in colour and comprising a single protective layer these bags are normally identified by a printed symbol or an all-over, cross-hatched printed effect. They have all the properties of a static shielding bag but do not shield the contents from static damage.

Away from the electronics industry the bags have been used for house invitations, CDs and cosmetics to name a few. They are attractive to designers for their allusions to futuristic and industrial themes. They are available as open-topped for vacuum sealing, with a grip-seal closure and also with a peel and seal closure.

BeeCore®

BeeCore® is the trade name for the honeycomb core of BeeBoard®. For many years it has been used as the core material within car doors. The hexagonal cell construction of the core material is one of the strongest cell structures that exist in nature. Coupled with the board laminated to both sides of the material it creates an incredibly strong and lightweight substance that can withstand high levels of pressure. The thickness of the material is determined by the depth the honeycomb core is cut to. Interestingly there is an aluminium version that aircraft fuselages are made from.

Bubble wrap

The above term is a catch-all phrase that encompasses a labyrinthine world of packaging products. Bubble packaging or air cellular packaging uses the air trapped inside the polythene cavities to protect products from damage. There are many grades of bubble wrap but it is important to choose a quality that can retain air over a long period of time. All bubble wrap is made from polythene. However, polythene alone offers poor air retention so it is important to use a thicker film if the bubble wrap is to have longevity. There are many grades including flame retardant, anti-static and even a Ministry of Defence specified grade. Size of individual bubbles ranges from 10mm diameter to 32mm diameter. Note that it is not possible to print on existing bubble wrap. The ink does not adhere to the polythene and flakes off.

Canvas

There are an infinite variety of cotton-canvas
materials available in different grades
depending where it is sourced. It can be
stitched to form pouches or used to line or
cover packaging giving an environmental or
quasi-industrial finish. Try stencilling the print
instead of printing.

Chipboard/Grey board

The briefest description would be to say that
these boards are made from waste paper
which goes through a number of stages
before it is converted into finished material.

Bales of waste paper are tipped into a large
steel cauldron or pulper, filled with water,
and fitted with a rotor arm. The soaked waste
paper starts to break up and the turbulence
produced by the rotor arm mixes the fibres
with the water. Paper makers refer to this
mixture of water and fibre as the 'stock'.
Materials such as plastics that have got
into the stock are removed. This stock is
still far from suitable for the production of
board. These other materials are removed
through a series of cleaners, screenplates
and deflakers.

The start of board formation is also the most
critical of the entire production process.
A factor of great importance at this stage
is the ratio of fibres to water content. For
the production of board the proportion is
approximately 1–2% fibres to 98–99% water.
The fibres and water mixture is pumped and
distributed onto an endless screen or 'wire'. It
is in the first few metres of the 'wire' that the
board takes shape. The water disperses, and
the paper fibres remain behind and bind to
each other. To facilitate and speed up the de-
watering, suction boxes are added to suck the
water from the stock. The board still contains
around 70% water.

The wet board is transported and squeezed
between two presses where supporting felts
soak up and remove the water. Although, at
first glance the board looks more rigid it still
contains 50% water.

The drying section is the last phase of the
de-watering process. The board is
transported over steam-heated rollers. The
high temperatures enable the bulk of the
remaining water to evaporate. The vapour
disappears into extractors. The final board
now contains an average of 92% fibres and
8% water. The board is then left in this state or
is laminated or pasted to create thicker board
or different finishes. The material is used for
practically everything from toilet roll cores to
food packaging to book covers. It screen-
prints well, though a considerable quantity of
thinner is need to prevent the ink soaking in,
and incredible results can be achieved
through foil blocking.

Cork

As a material it can be used to cover and line boxes (some suppliers of book-binding cloth supply a binding grade). As a solid block it would be difficult to cut and carve to create high volumes of packaging but it is certainly worth experimenting with. Caution needs to be exercised when screen printing.

Corrugated board

Corrugated board is an extremely durable, versatile and lightweight material principally used for shipping containers, outer packaging and point of sale.

It has two main components – the liner board and the medium. The liner board is the material that adheres to the medium. The medium is the wavy, fluted paper in between the liners. This combines in single face (the liner board is mounted to one side of the medium), single wall (the liner board is mounted to both sides of the medium), double wall (three sheets of liner board with two mediums in between) and triple wall (four sheets of liner board and three mediums in between).

If you look closely at the medium you will notice that it forms a series of peaks or arches. These arches are known as flutes and when anchored to liner board with a starch-based adhesive, they resist bending and pressure from all directions.

These flutes come in several standard shapes or profiles. A-flute is the largest flute profile followed by B-flute commonly used on most outer boxes used for shipping. E-flute is one of the smallest and is the most ideal material for presentation boxes with the not so widely available F-flute being the smallest.

All of these materials have very specific uses within the packaging and logistics industry but can be used for their aesthetics on more specialised packaging formats. It is the best example of a material that alludes to industrial and environmental themes and is a great substrate for box prototyping.

Denim

A relation of canvas and not strictly the
preserve of clothing. Some suppliers of book-
binding cloth will coat the reverse so you can
cover and line your packaging. If you want to
distress denim use a cheese grater.
Sandpaper does not work.

Fake fur

Fake fur is made from anything from nylon
and rayon to acrylic. It comes with a wide
variety of backings and is supplied in
numerous shades, patterns and piles.

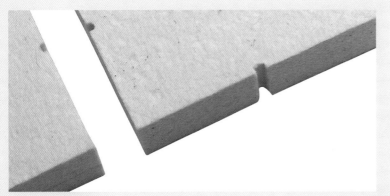

Felt

Felt is a non-woven fabric manufactured either solely from wool or from a wool-blended mixture. Manufactured by means of compression, heat and moisture its construction depends on the unique properties of the wool fibre. The wool fibres are unlike any other natural hair products in that their surface structure is comprised of raised 'scales', which naturally interlock with each other when compressed together. This interlocking of fibres results in a structure that can be further enhanced with milling and hardening – the felting stage. The more the wool is felted the firmer and denser it

becomes. The material's final firmness is in direct proportion to the amount of felting it has received. Once the specific grade of felt has been manufactured, the fabric is dried under tension to stabilise the required thickness and width.

Its application varies from the industrial on the one hand (polishing and deburring of metals) to its use as washers, seals and shock absorbers in engines to drum beater balls and cymbal washers to clothing and children's toys. Although difficult to print, the results are very pleasing if one is patient.

Foam

Foam is made up of a series of cells that basically do not communicate with each other, therefore not allowing any air to pass through them. This means that the harder the foam the less air is being allowed to pass through it.

Foam is manufactured by melting raw polyethylene granules in an extruder. If a specific colour is required then the pigment is introduced at this stage. The extrusion process creates a solid piece of raw polyethylene plastic with a thickness of roughly 10mm. This sheet is then put into a high-pressure autoclave and softened at very high temperatures. During this softening process nitrogen is forced into the plastic, soaking the material. The sheet is then placed in another autoclave at a lower pressure and heated once more. During this heating process the nitrogen tries to heat and expand but it is not allowed to escape until the autoclave pressure is reduced. Over a period of roughly half an hour the nitrogen expands allowing the polyethylene block to expand.

Foam has a wide variety of uses from swimming floats to sleeping mats to soccer shin pads. It is used for its protective qualities first and foremost, with more open-cell foams being used for water filtration and acoustic cushioning. It can be cut, moulded and materials can be laminated to it. CNC routing of foam is another process that provides great results. The material is cut via a high-speed grinding bit that is lowered into the foam to certain depths. In most cases the routing bit is stationary and the foam moves in the table underneath, but this process can be carried out the opposite way round.

Foam can be disposed of by incineration and the energy given off can then be re-used.

Glass

The use of glass in packaging has been overtaken by Perspex, as it is more flexible and cheaper. However, it is an exciting challenge to undertake but care should be taken when gluing as the glue lines will be very visible.

Glow-edge acrylic

All acrylics are principally manufactured by a cast process. This is where an acrylic liquid syrup is cast between two sheets of toughened glass and allowed to cool. It is at this casting stage that fluorescent particles and pigments are introduced. The finished material has the ability to pick up light on its edges and reflect it back. It also refracts light across its surface or through anything that is engraved into it. Put another way glow-edge acrylic transforms UV light into visible light.

Hessian

With hessian being a very coarse material it is difficult to print and can only be stitched into very rudimentary pouches. However, you can still find suppliers of hessian wallpaper which is smoother and can be mounted to board.

Kinetic PVC

Kinetic PVC is multi-lensed-effect plastic manufactured in vinyl, polycarbonate or cellulose propionate. The effect of motion and dimension is achieved through thousands of minute parabolic lenses moulded on both sides of the surface. These lenses create shimmering patterns, star dust sparkles, shimmering silk and geometric repetition. It can be printed, but solvent-based inks are to be avoided as they have a tendency to cockle the material. Foil blocking is very effective. There is a rigid grade and a high-frequency weldable grade.

Leather

As much of a luxury as using glass for
packaging executions, leather comes in a
wide variety of thicknesses, colours and
qualities. If it is mounted it has a tendency
to shrink back. However, there are a great
variety of leather-look book-binding cloths
available for you to use.

Liquid-filled plastic

The liquid comprises the majority of chemicals
commonly found in hair gel minus the
colouring and perfume. The liquid is then
high-frequency welded into flexible PVC.
Please be aware that they have to be handled
with care, as they will burst if mishandled.

Metal sheet

Stainless steel can be etched and printed and folded to shape. Joining a flat sheet together to form a box can be expensive. It is worth pointing out that there are a limited number of pressed tins available with tooling being very expensive if you want a specific size.

Mirriboard

Mirriboard is produced by laminating a 12-micron metalicised polyester film to board to give an optical mirror-finished material. The different colours are created by dying the raw film prior to lamination. The film is laminated reel to reel at high speed and rewound onto another reel. The reel is then sheeted to the required size. The reverse of the material is normally uncoated.

There are many grades of mirror finish and this is reflected in the price per sheet. This same process can be applied to a very wide range of holographic patterns that are currently available. While the technical specifications for these products always assure the end user of its printability it is notoriously difficult to achieve a result. There are only a certain number of inks which will print and dry on it, but the results are staggering. When it is debossed it can look like stamped metal. When it is foil blocked with a metallic foil the results are very striking. It die-cuts and creases very well but care must be taken, as it scratches and marks easily during the finishing stages of production.

Perspex

Perspex is one of the world's most popular acrylics. It is ideal as it is available in both cast and extruded sheets making it very adaptable. The cast sheets have a high molecular weight and are therefore very strong and easy to construct. The extruded sheets have a low molecular structure making it ideal to vacuum form – a process which is particularly useful for packaging manufacture. Perspex is made in 55 different colours making it particularly versatile but if there is not the colour that your design requires it can be custom-made in a colour specific to your needs. This is an adaptable 'cheap and cheerful' material for packaging which benefits from being particularly durable.

Polypropylene

Polypropylene has a strangely waxy feel and is similar in look to PVC. Granules of polypropylene are fed into an extruder where the granules are melted down and pass through a very fine extrusion opening in one continuous stream. This forms a continuous sheet which is then fed through an embossing cylinder and cut to provide finished sheets. Colour is created for the sheet at the extrusion stage. It is an extremely versatile material and can be printed, foil-blocked and embossed to name a few.

Before polypropylene was invented the gases that are integral to its manufacture, propylene and ethylene, were simply burnt. These gases are now used in manufacture. Polypropylene does not give off gases when burnt and the companies that produce the material are very active in ensuring that all waste is recycled.

The material is available in a wide selection of colours from stock in varying weights. It must be pointed out that the material thickness can vary across a sheet which can present problems when die-cutting and creasing in a high-volume production run.

Pulp-carton mouldings

The pulp slurry is very much like the raw material found in the production of grey board. The designs are pressed out under enormous pressure. It is a terrific form of packaging but, at time of writing, the tooling costs and minimum orders make it prohibitive.

PVC

PVC or polyvinyl chloride is another material from the plastics family. It is predominately comprised of chlorine, itself derived from salt. It was first synthesised from salt in 1872 and was commercially developed in the 1930s. Its dominance as a material grew in the 1940s due to shortages in other raw materials and has since become the most diverse material currently available, with a multitude of variants. Its principal applications are for long-term use in the medical and industrial fields as a material that can be relied on for high performance and durability, and also in bottles where it does not taint the contents.

In recent years PVC has come under a great deal of fire from the environmental lobby. No material is safe from these issues. However, PVC is fully recyclable and is easily retrieved from the waste stream of the world. For example, a plastic drink bottle can be recycled into drain pipe. It is an inert material when buried and does not contribute to methane or other toxic gas build-up. It can also be incinerated without any release of harmful dioxins. The use of PVC grades other than presentation grades can add new dynamics to packaging.

Rubber

Rubber is available in sheet form and is
principally used as industrial flooring. It has
to be printed with flexible inks for obvious
reasons, and mounted to board with
special adhesives.

Space-age materials

Packaging materials need not be dull and
conventional, and exotic materials are often
the easiest way to promote a message of
extravagance and luxury.

Styrofoam

With high tooling cost this form of packaging is beyond the realms of some projects but you can create futuristic and space-age results.

Tyvek

Tyvek is made from 100% high-density polyethylene (certain extruded polyethylenes are used to manufacture carrier bags), manufactured by first spinning continuous filaments of very fine, interconnected fibres and then bonding them together with a combination of heat and pressure. The material is white, non-toxic and chemically inert. The finished sheet is extremely tough and does not rip easily. Its uses have been exploited in more industrial applications for protective clothing tags and signs, its technical/medical/industrial feel only recently being exploited on products in everyday consumer use. The material can be printed using all methods, creased and die-cut. It can also be foil blocked. An interesting process is to place Tyvek under the heated die of a foil blocking machine. The resulting blocked or debossed area becomes clear. This process is not encouraged by the material manufacturers but this material is an ideal candidate for experimentation.

Further research into this material renders other grades that have very specific applications but are not offered to designers and end users because their uses are specifically industrial.

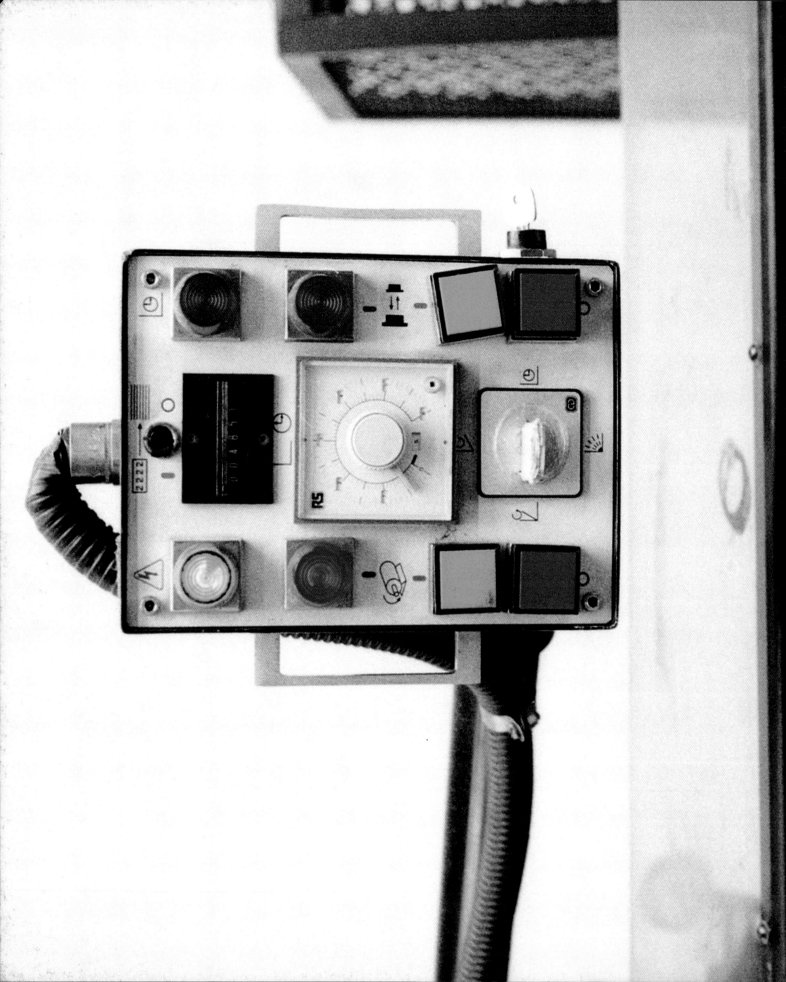

05_Processes

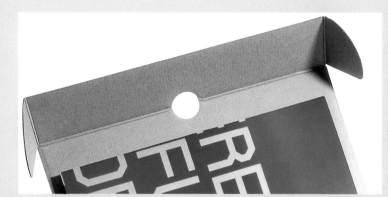

Closures

There are five common styles for carton closures. The closure is an important part of the carton, not only providing rigidity for the container but also creating a point of interest to the overall execution, particularly if you are using materials other than board.

Firstly, there is the standard tuck-in flap closure which can be given added strength by incorporating a slit on the edges of the flap creating a Slit Lock. This closure, however, is prone to damage over a period of time and does not remain secure forever, particularly in board. Secondly, there is the Tab Lock. This incorporates the basic tuck-in flap with a further tab positioned centrally in the centre of the open edge. The closures get more complicated with a Postal Lock.

You can build other types of closures into the cutter creating a zipper closure (as seen on washing-up powder boxes) or you can integrate the closure completely into the packaging. For example, the zipper-rule closure can cover the whole surface of the carton, making the end user completely destroy the box on opening. In the cause of exploration one could take any of the above closures and make it the main feature of the structure, not just something that is hidden.

Die cutting

A die, cutting die, die form or cutter is a piece of wood that contains creasing and cutting rules that make up the form to die cut any given material. In simple terms the creasing rules are blunt and the cutting rules are sharp. There are normally lines on either side with high-density foam. Note that it is not always accurate to cut different materials with the same cutter, as the cut, creased and folded result may not be the same from one to the other.

Die cutting is the use of sharp steel rules to cut the clients' desired shapes. Die cutting can be done on a flat-bed plate or rotary press.

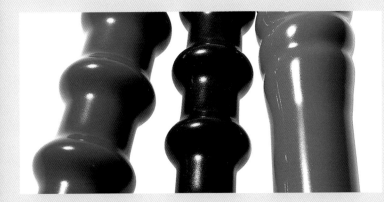

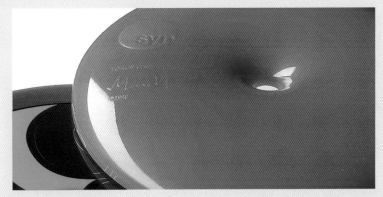

Dip moulding

Dip moulding is exactly what the name suggests: a cast or machined aluminium forming is pre-heated and dipped in a PVC Plastisol liquid (plasticiser determines the hardness of the PVC – in this case very soft) and allowed to semi-harden. The forming is then removed from the PVC liquid and placed in an oven to cure. After cooling the mould is stripped from the forming. Though not as precise as injection moulding it is a lot more cost-effective and allows you to do shorter production runs.

The most obvious limitation of dip moulding is the use of a 'male'-only forming which gives a hollow moulding while also being flexible and never rigid. One only needs to look at caravan tow bars and bicycle handles for further clarification of its application.

Injection moulding

Injection moulding is what is termed as a cyclic process in which a soft material (usually softened by heat) is injected into a mould from which it is ejected after it has set to the shape of the cavity. Injection moulding is the most common moulding process used by the plastics industry and, after extrusion, the greatest user of plastic materials.

In the moulding process, two mould halves are clamped together and the thermally softened material (a melt) is injected from a barrel into the cavity containing the two mould halves. To obtain the mould-filling speeds required, high-injection moulding pressures are used; this in turn means that high clamping pressures are necessary.

In order to stop the mould from being over filled when extra material is packed into the mould to compensate for shrinkage a reduced second-stage pressure, or hold pressure, may be used. The moulded component then sets to the shape of the cavity as the injection mould is operated at a temperature appropriate for the material.

When the part has set to the shape of the cavity (this is the longest part of the mould cycle) the mould is opened and the component is ejected so that the process can begin again.

The process is used very extensively for thermoplastics: virtually every thermoplastic material is injection moulded. For such materials the mould is kept cooler than the melt so as to achieve setting. With slight modifications the process may also be used for thermosetting plastics and for rubbers. For such materials the mould is kept hotter than the melt, so as to achieve setting, and the the barrel of the machine is kept cooler than the mould.

Injection moulding is a mass production or repetitive process which is capable, when operated correctly, of producing very large numbers of identical complex mouldings at a high production rate. This may require little or no finishing (the Cultural Ties packaging demanded a high degree) although their appearance may be enhanced, if required, by a range of decorating techniques (see the logo on the Cultural Ties packaging).

Because of the high equipment costs, injection mouldings are usually comparatively small and include pen tops, shampoo bottle tops and plumbing fixtures. Large mouldings can be produced but the tooling is exponentially more expensive and the moulds take longer to set.

Consideration has to be made with regard to the correct material for the end use.

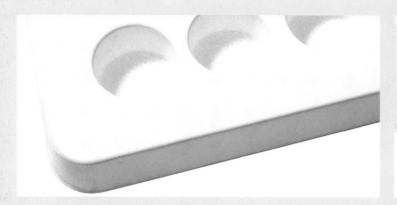

Thermoforming

THERMOFORMING – The method of processing finished items from all kinds of rigid plastic sheet. The sheet is heated to its particular thermoforming temperature and immediately shaped to its desired result. At the required temperature the material is very pliable, enabling it to be formed rapidly and in great detail. The pressure is maintained on the material until it has cooled into the desired shape; it is then trimmed out.

It was the Romans who originally began thermoforming tortoise sheel (keratin) using basic tooling and hot oil to create cooking utensils. During the Second World War the process was used to create aircraft canopies, turrets, domes and relief maps of bombing targets. The war provided the platform for thermoforming to be regarded as a profitable method of processing plastics.

Thermoforming requires a tool to be designed and manufactured. Prototypes and short runs are undertaken using tooling made of wood, plaster or resin. The results are not as accurate as a cast and engraved tool but it is more cost-effective and quicker to produce. A prototyping tool has a limited life as the pressure of the process degenerates it. The steel tool is the best method for long production runs.

Many people are put off by the high tooling costs and long manufacturing times but it is an interesting process to explore if budget permits.

Welding

HIGH-FREQUENCY WELDING – This is the process of fusing materials together by applying high-frequency energy to the area to be joined. The energy produces localised heating of the materials, causing them to soften and melt, thus allowing their molecules to intermingle. After a period of cooling, the materials become joined together at the point of the weld, creating a very strong bond.

The most widely used material in high frequency (HF) welding is PVC, otherwise known as vinyl. It is important to note that not all thin, flexible thermoplastics can be HF welded; the suitability of a plastic for HF welding is determined by its molecular construction; polythene sheeting, for example is not suitable for this process.

As I have pointed out HF welding fuses the material at high temperatures but this is further augmented by applying pressure. There are two types of HF welding:

PLAIN WELDING – The welding of two or more thicknesses of material, the welding tool being engraved to give a decorative appearance.

TEAR-SEAL WELDING – The dual process of simultaneously welding and cutting a material. This is achieved incorporating a cutting edge adjacent to the welding edge. This compresses the hot PVC enough to allow the scrap material to be torn off. This technique can be employed to create cut-outs in the material.

Welding continued

The welding process can incorporate 'blind' embossing which places lettering, logos or decorative effects onto the welded items. If the material that is to be welded has been printed it is important to use non-arcing inks. If these are not used the material will not weld and will blow apart.

The process is applied to all manner of items from stationery right through to blood and colostomy bags. The range of weldable materials is infinite and, like Tyvek, it is interesting to research other grades and use them in other areas where they would not normally be used.

The origin of HF welding is closely associated with the early days of radio and radar when the heating effect of radio waves was discovered. Since then, the development of thermoplastic materials and HF welding have progressed hand in hand, enabling new materials and machines necessary to weld them to be manufactured.

ULTRA-SONIC WELDING – This can loosely be regarded as an alternative to gluing, particularly in respect of plastic products, polypropylene in particular. Adhesive tapes and glues have a tendency to react with the materials they are applied to, allowing them to dry up or migrate out of the folded material. Ultra-sonic welding is a neater solution and is rarely explored.

A tool called a sonotrode is vertically vibrated by an ultra-sound generator at frequencies between 20 khz and 40 khz. The frequency is the number of vibrations per second, 20 khz corresponding to 20,000 vibrations per second. The weld usually manifests itself as a spot, the ultra-sonic energy being concentrated into a tooth which is cut into the sonotrode. The difference in speed between the vibrating sonotrode and the material produces a rise in temperature which results in the fusion of the material. Although the weld manifests itself as a spot you can also specify different decorative effects. However, the spot-welded finish is decorative in itself. It is important to point out that welding too close to a crease in the material can force it to split.

HOT-AIR WELDING – As a process it has similarities to ultra-sonic welding. The material is softened where the weld is required with hot air. Both surfaces must be at the same temperature. The weld created is similar to a length of double-sided tape when viewed on clear materials. It is, however, far more durable.

ABS
Acrylonitrile Butadiene Styrene

ASA
Acrylate Styrene Acrylonitrile

ACS
Acrylonitrile Styrene

AES
Acrylonitrile Styrene/ EP (D) M rubber

EP
Epoxy

EPS
Expanded Polystyrene

EVA
Ethylene Vinyl Acetate

HDPE
High Density Polyethylene

PA
Polyamide (nylon)

PBT
Polybutylene Terepthalate

PC
Polycarbonate

PE
Polyethylene

PF
Phenol Formaldehyde (phenolics)

PMMA
Polymethyl Methacrylate (acrylic)

POM
Polyoxymethylene (polyacetal)

PP
Polypropylene

PU
Polyurethane

PVA
Polyvinyl Alcohol

PVC
Poly(vinyl chloride)

PVC-P
Plasticised Poly(vinyl chloride)

TPU
Thermoplastic Polyurethane

BMC Bulk-Moulded Compound	**CA** Cellulose Acetate	**CNC** Computerised Numerical Control	**DMC** Dough-Moulding Compound
HIPS High-Impact Polystyrene	**LDPE** Low-Density Polyethylene	**MF** Melamine Formaldehyde	**OPP** Oriented Polypropylene
PEEK Polyetheretherketone	**PES** Polyether Sulphone	**PET** Polyethylene Terephthalate	**PI** Polyimide
PPE Polyphenylene Ether	**PS** Polystyrene	**PSU** Polysulphone	**PTFE** Polytetrafluoroethylene
SAN Styrenelacrylonitrile	**SB** Styrene butadiene	**SBS** Styrenelbutadiene/styrene block copolymer	**SI** Silicone
	TPO Thermoplastic Olefin		**UP** Unsaturated polyester

06_Templates

The next few pages feature some basic box templates. While they appear to be quite familiar forms they do present an invaluable grounding from which to explore all manner of materials and processes.

From this point it is possible to create these basic shapes and manipulate them to create new structures, imagining how the end user would interact with the packaging.

There is no replacement for the opportunity to experiment with different materials to see how they perform. But one must also bear in mind how the designs will ultimately be produced in manufacture. It would be wrong to create something that is impossible to make.

Ask your local paper merchant about availability of material. However, you must remember that, you can create boxes and cartons from the material that is lying around you. The notion of using found materials is not a new invention but it can be commandeered at the initial prototyping stages to speed up the creation process.

Choice of materials is very important in deciding how the packaging will look. Issues of protection and stackability should be the furthest from your mind as they hinder new ideas. The material should be the notional aspect of the whole idea. Questions of what sort of emotional values you want to instil in the end user are paramount. What are the values you want to put across? Is the packaging meant to feel futuristic, industrial, recycled or expensive? The codes lie beyond the packaging itself and are drawn from the outside world, principally popular culture.

The possibility of appropriating the vernacular language of unrelated industries is also a rich vein of packaging ideas – using pharmaceutical packaging to package cosmetics, for example.

This section devotes a lot of attention to closures as they are the most difficult to achieve in materials other than cardboard. There are opportunities to convert the closure device into something that is integral to the overall design. The idea is to exploit the notion of packaging as sculpture either by making the end user aware of its construction or to obscure it.

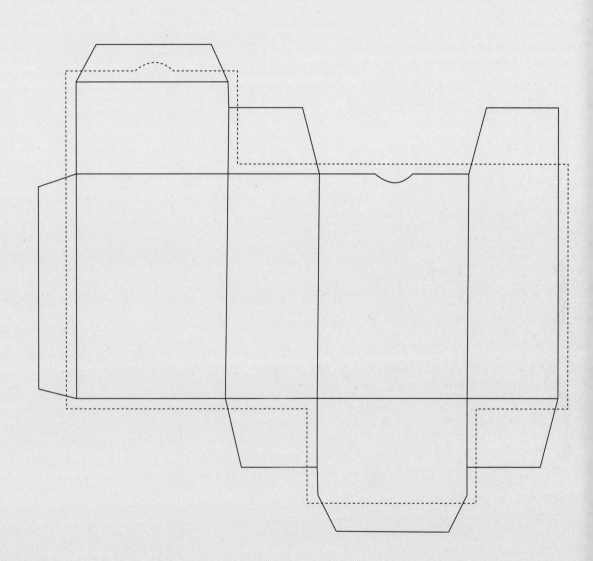

A typical carton, when laid flat forms an 'S'
shape. For economy these are laid head to toe
to get as many as possible onto one sheet of
paper. If there is any space left over why not
run some business cards of your own onto
the same sheet. The dust panels and glue
flaps should not be ignored. They are a
surface that can be designed on as well.

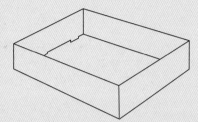

Double end wall and self-locking tray

Try doubling over the other two walls to
achieve greater strength and prolong usage.

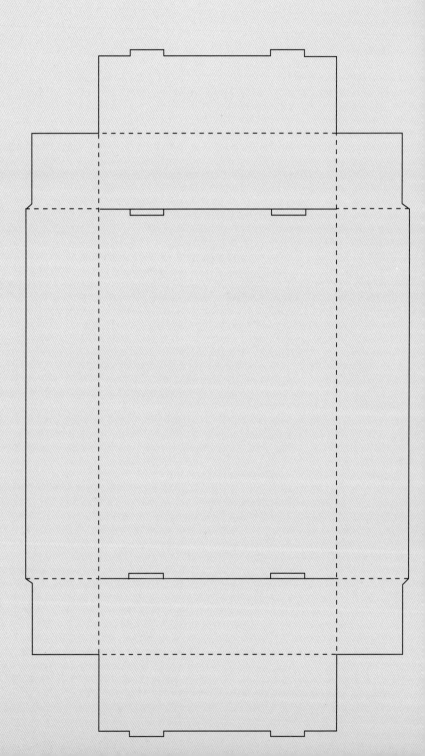

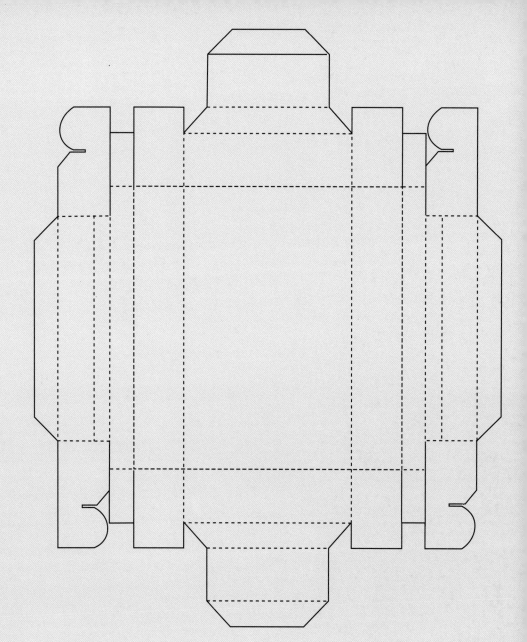

Self-locking hollow walls

The description goes nowhere near the production problems of finishing this in large quantities. Be mindful of production lead times.

Simple folder

A construction that is ideal for experimenting
on different materials.

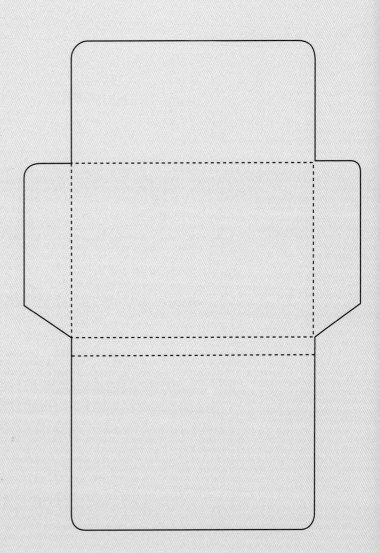

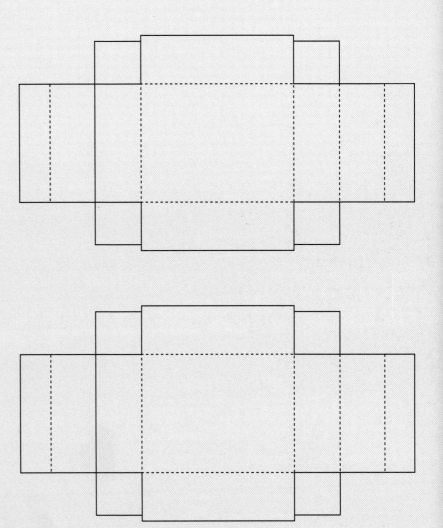

**Two-piece full telescopic
friction-lock tray**

The friction is caused by the vacuum created
by the full-depth lid. This problem can be
alleviated by making the lid shallower than the
base or by including thumb cuts on the sides
of the lid. The design would need to be
modified depending on the material.

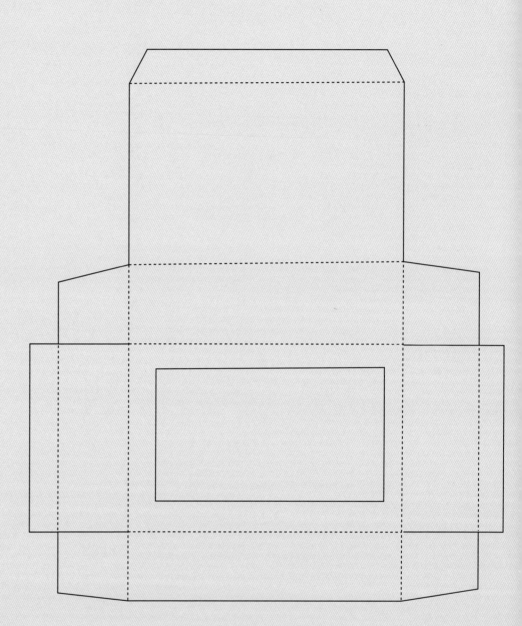

Window carton

The window is die cut at the same time as the box form is punched out of the sheet. Note that the more complicated the window shape the potentially more expensive the cutter.

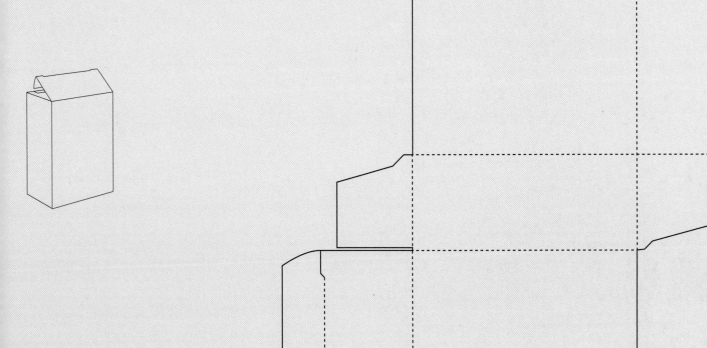

Reverse tuck

Commonly used in the pharmaceutical
industry for pill cartons. The locking tabs are
needed on cartons with a very small depth.
The die cut nick deteriorates after its first use.

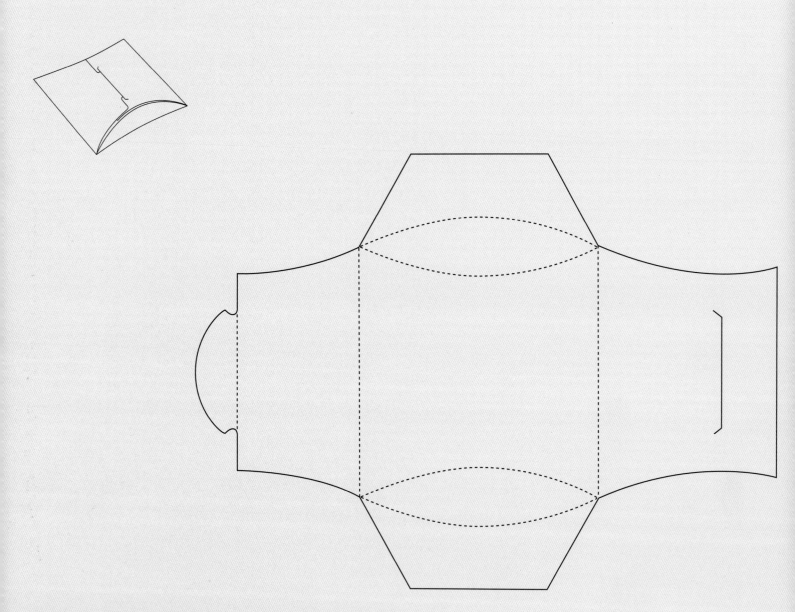

Pillow pack with tuck

No gluing and an interesting closure make it
an economical and versatile construction.

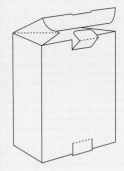

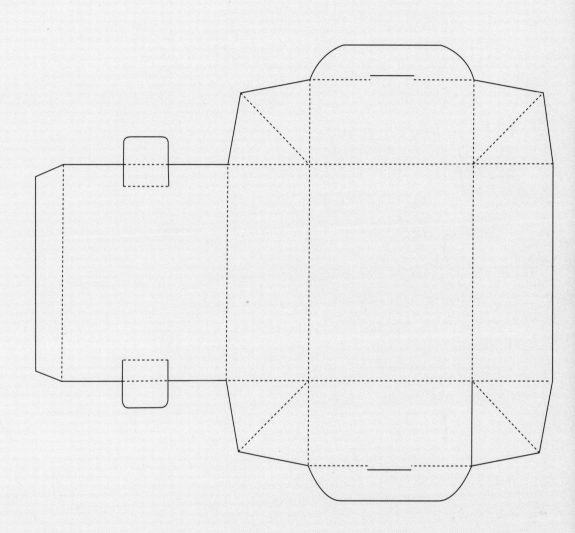

Tuck and tongue with gusset flap

The inclusion of the tab on the back panel
gives greater strength but can compromise
the graphics. The gusset dust flap needs to
be held down with this style of closure
because of the large amount of material at
the top and bottom.

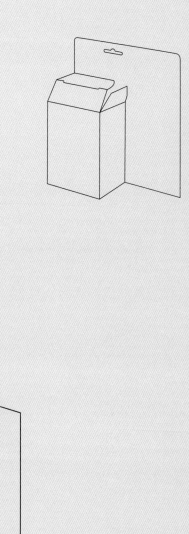

Straight tuck with fifth panel

An alternative to packaging and presenting.
The carton element could incorporate
a window.

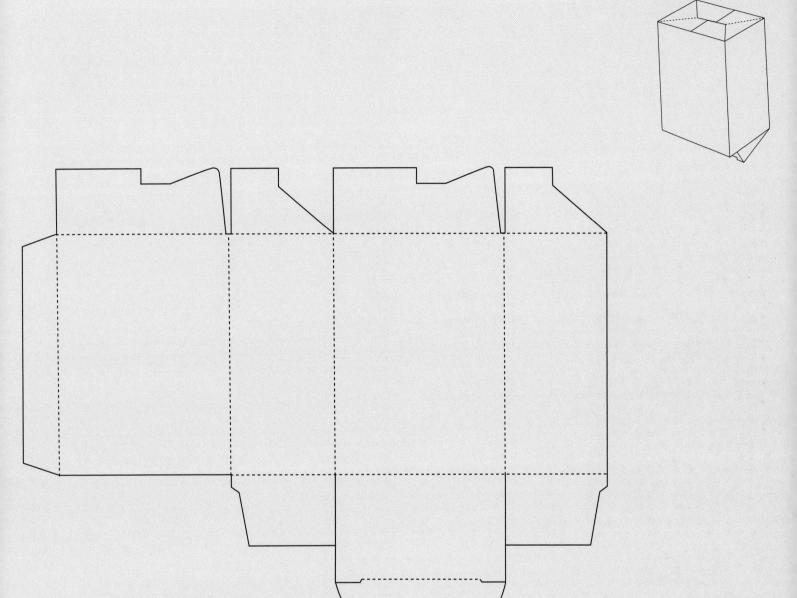

Tuck with auto-lock bottom

You sometimes see this locking bottom on
cardboard shoe boxes yet the base closure
works well on PVC or polypropylene.

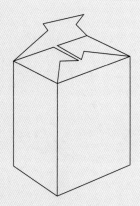

Reinforced snap-lock bottom

The simplest carton to construct, as well as
the strongest.

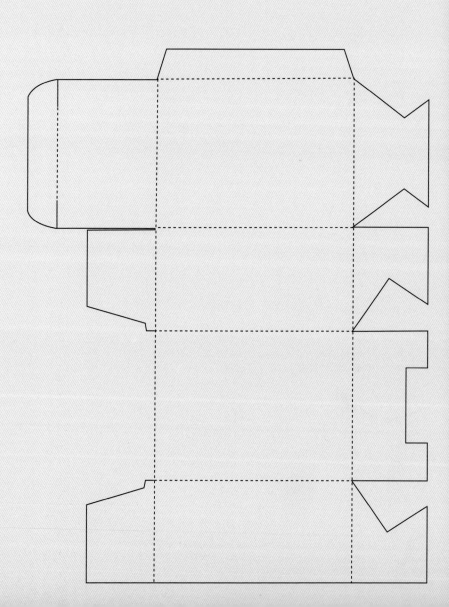

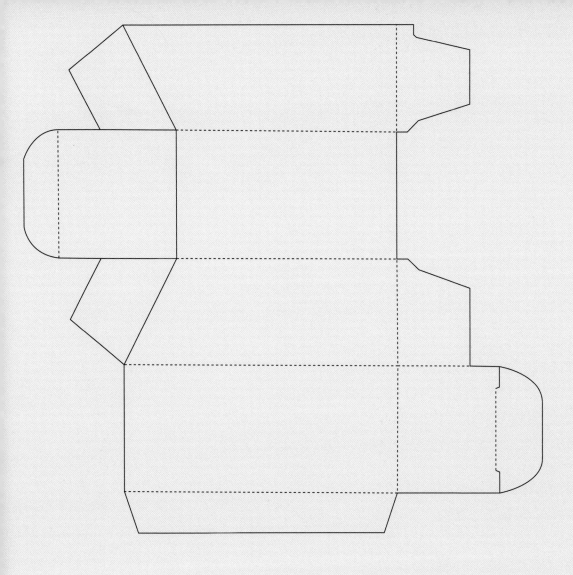

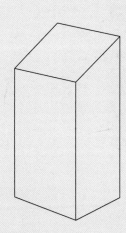

Reverse tuck with tapered top

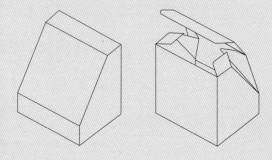

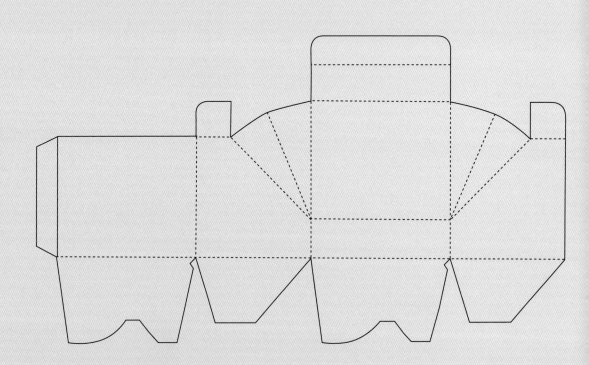

Faceted top

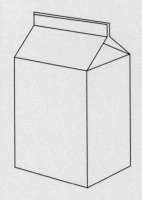

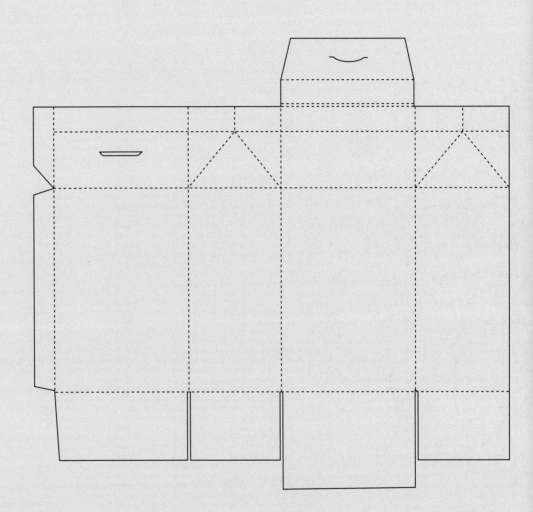

Milk carton-style

A recognisable carton execution for a specific
job. It is illustrated with a tuck-in flap closure.
Magnetic strip or Velcro are alternatives.

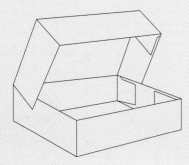

One-piece tray/lid with glued corners

This execution only really works with board. You can ultra-sonically weld polypropylene to form a similar construction. However, the lid needs to have locking tabs on the sides of the box to prevent the material from bowing too much.

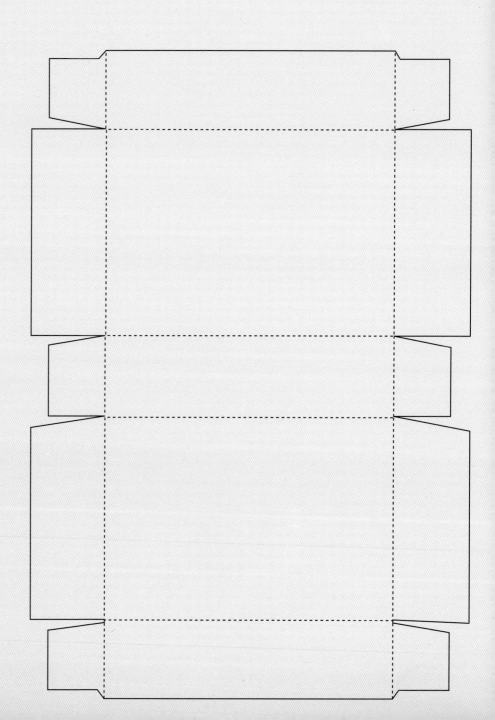

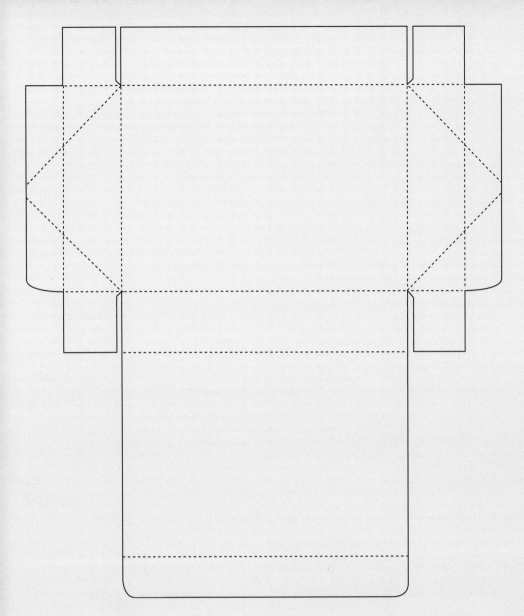

**One-piece collapsible tray/
lid with dust flap**

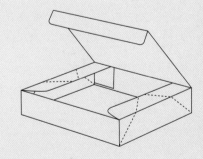

POLYTHENE BAGS

SIZE: 24 X 30"
GAUGE: 500
COLOUR: CLEAR
ORDER No: STOCK
ITEM CODE: 2430500NS
BATCH No: 115751
QUANTITY: 100

07_Acknowledgements

I would like to thank all of the people who submitted work for the content of this book, especially Oliver at Mowax, Robert at YMC, Ezra at Work in Progress, Mason at North, Gareth at Alias, Ilaria Martini and Clarice Pecori Giraldi of Prada, Jan Sharkansky and Holly Jordan of C.I.D, Ben Ponton of :zoviet*france:, Mandy Plumb at Parlaphone, Keigo Oyamada, Farah Frayeh Yazawa, Shane Woolman, Tony Hung of Adjective Noun, Rebecca and Mike, Kohei and Vince Frost, Hans and Veronika at hdr design, Lisbeth at Lindberg Optic. Your contributions and advice have been invaluable. Keep continuing to create. Thank you to Roger for all your help and advice, and to Xavier for photographing the examples with such care and attention. I would also like to thank Zara and Laura for their patience in what has been an interesting journey. I hope to continue with it. Finally all my love goes to Chloe.

Daniel Mason works for London-based printers Artomatic, a company with an unrivalled reputation for creating innovative and uncompromising print and packaging solutions for the world's leading graphic designers and design groups. They have two sites, a factory in West London and a print and materials archive in East London.